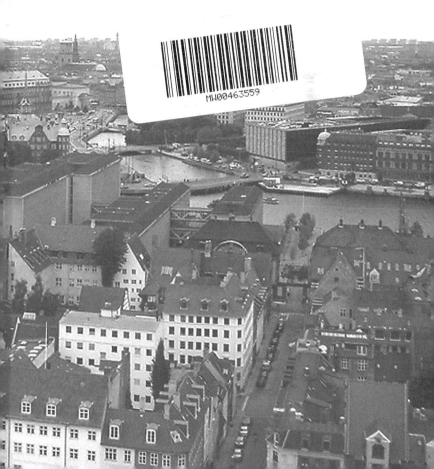

COPENHAGEN
architecture & design

Edited and written by Christian Datz and Christof Kullmann
Concept by Martin Nicholas Kunz

teNeues

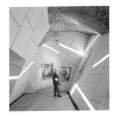
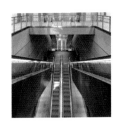

to see . culture & education

to see . public

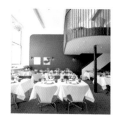

to stay . hotels

to go . eating, drinking, clubbing

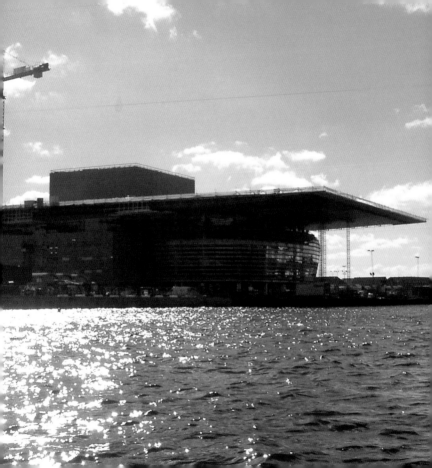

introduction

Nørrebro

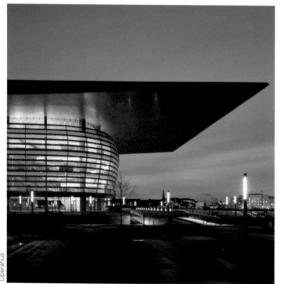

Operahus

Copenhagen is considered as one of the most important centers of modern design in Europe. Classical 20th century designers have left their mark in the city, like Arne Jacobsen, Jörn Utzon or Verner Panton. Yet the development continues. In the last few years, in particular, a whole series of spectacular and major projects were created in Copenhagen, as for instance, the extension of the Royal Library by Schmidt, Hammer & Lassen or the opera house by Henning Larsen. In addition, there are a variety of buildings and interiors by young Danish designers. These all show, impressively, that Scandinavian modernity has lost nothing of its aesthetic functionality and timeless elegance.

Kopenhagen gilt als eines der bedeutendsten Zentren des modernen Designs in Europa. Klassiker des 20. Jahrhunderts wie Arne Jacobsen, Jörn Utzon oder Verner Panton haben in der Stadt ihre Spuren hinterlassen. Jedoch: Die Entwicklung geht weiter. Gerade in den letzten Jahren entstand in Kopenhagen eine ganze Reihe von spektakulären Großprojekten, wie zum Beispiel die Erweiterung der Königlichen Bibliothek von Schmidt, Hammer & Lassen oder das Opernhaus von Henning Larsen. Dazu kommt eine Vielzahl von Bauten und Interieurs junger dänischer Designer. Diese belegen eindrucksvoll, dass die skandinavische Moderne nichts von Ihrer ästhetischen Funktionalität und zeitlosen Eleganz eingebüßt hat.

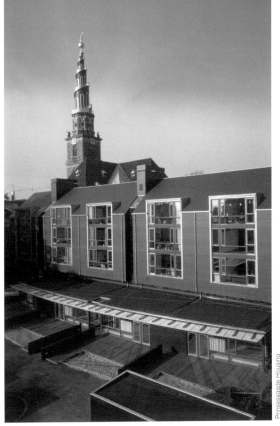

Prinsessgade Housing

9

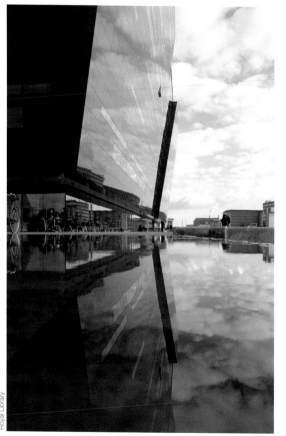

Copenhague passe pour être l'un des hauts lieux du design moderne en Europe. Des classiques du 20ème siècle tels que Arne Jacobsen, Jörn Utzon ou Verner Panton ont laissé leur empreinte dans la ville. Pourtant, le développement se poursuit. Ces dernières années précisément, une série de grands projets spectaculaires a vu le jour à Copenhague, comme par exemple l'extension de la bibliothèque royale de Schmidt, Hammer & Lassen ou l'opéra de Henning Larsen. Auxquels s'ajoutent une multitude de constructions et d'intérieurs créés par de jeunes designers danois. Ceux-ci témoignent de façon impressionnante que le modernisme scandinave n'a rien perdu de sa fonctionnalité esthétique ni de son élégance intemporelle.

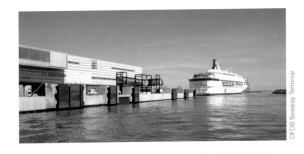

DFDS Seaway Terminal

Copenhague se considera uno de los más significativos centros del diseño moderno en Europa. Algunos clásicos del siglo XX, tales como Arne Jacobsen, Jörn Utzon y Verner Panton han dejado sus huellas en esta ciudad. Sin embargo el desarrollo continúa: en los últimos años Copenhague ha sido escenario de una serie de proyectos espectaculares como es el caso de la ampliación de la biblioteca real, de la mano de Schmidt, Hammer & Lassen, o la ópera de Henning Larsen. A ello se suma un número destacado de edificios e interiores concebidos por jóvenes diseñadores daneses. Todos ellos son una fascinante prueba de que el modernismo escandinavo no ha perdido nada de su funcionalidad estética y elegancia intemporal.

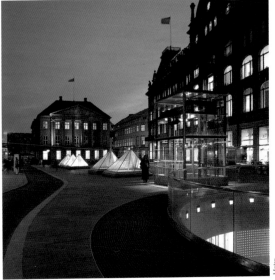

Metro

to see . living
office
culture & education
public

 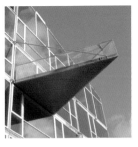

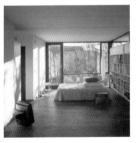 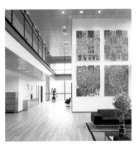

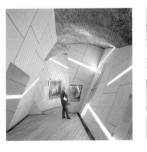 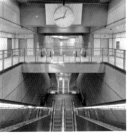 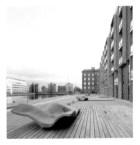

Krøyers Plads

(EEA) Erick van Egeraat associated architects

2009
Krøyers Plads
København K

www.eea-architects.com

The classical form of a house with sloping attic space is interpreted in an ironically strange and new way by the Krøyers Plads architects, who twisted, distorted and stretched normal dimensions. The three buildings are totally made out of glass; grills and slats serve as a sight and sun-screen.

Die klassische Form eines Hauses mit geneigten Dachflächen wird von den Architekten des Krøyers Plads durch Verdrehen, Verzerren und Strecken der normalen Dimensionen ironisch verfremdet und neu interpretiert. Die drei Baukörper werden vollständig verglast; Gitter und Lamellen dienen als Blick- und Sonnenschutz.

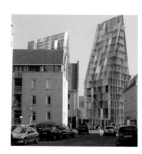

Les architectes du Krøyers Plads détournent avec ironie la forme classique de la maison avec toit incliné et en livrent leur propre interprétation en faussant, déformant et étirant les dimensions normales. Les trois bâtiments seront complètement vitrés ; des grilles et des lamelles serviront de protection contre les regards et le soleil.

Los arquitectos de Krøyers Plads transforman y reinterpretan irónicamente la forma clásica de los tejados inclinados distorsionando, retorciendo y estirando sus dimensiones normales. Los tres cuerpos están completamente acristalados y cuentan con una serie de rejas protectoras para el sol y para las vistas.

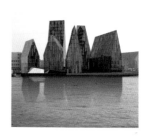

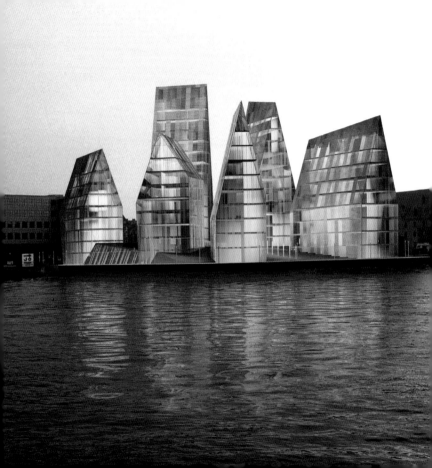

Prinsessegade Housing

tegnestuen vandkunsten ApS
Lemming & Eriksson A/S (SE)

2000
Prinsessegade 56-60
København K

www.vandkunsten.com
www.lemming-eriksson.dk

These 18 apartments and a kindergarten were created after a competition was held for good-value, social housing. The precise geometry and brief details give the buildings lots of aesthetic charm. The supply lines servicing the building were not concealed in shafts, but visibly trained through the staircases.

Anlässlich eines Wettbewerbes für preiswerten sozialen Wohnungsbau entstanden diese 18 Wohnungen und ein Kindergarten. Die präzise Geometrie und die knappen Details verleihen den Gebäuden einen hohen ästhetischen Reiz. Die Versorgungsleitungen wurden nicht in Schächten versteckt, sondern offen sichtbar durch die Treppenhäuser geführt.

C'est à l'occasion d'un concours pour la construction de logements sociaux qu'ont été construits ces 18 appartements et un jardin d'enfants. La géométrie précise et les détails stricts donnent aux bâtiments un attrait esthétique incontestable. Les conduites d'alimentation n'ont pas été dissimulées dans des puits mais passent ouvertement dans les cages d'escalier.

Los 18 pisos y el jardín de infancia fueron edificados con motivo de un concurso de construcción de viviendas de protección oficial asequibles. La precisión de la geometría y la austeridad en detalles dotan a los edificios de una especial atracción estética. Las conducciones de suministro no están cubiertas sino que se han distribuido por las escaleras de forma visible.

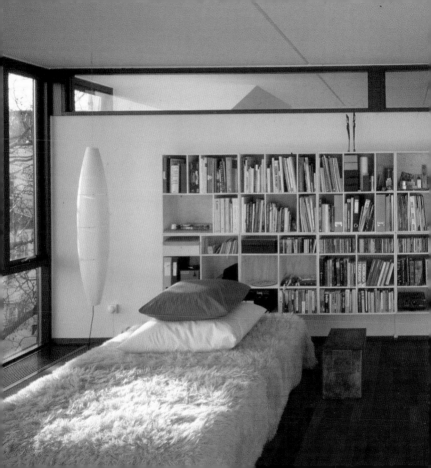

Torpedo Boat Hall

tegnestuen vandkunsten ApS
NIRAS A/S (SE)

2003
Galionsvej 1-9
København K

www.vandkunsten.com
www.niras.dk

The former servicing yard for torpedo boats was built in the 1950's and now transformed into an extraordinary apartment block. The two lower floors serve as parking decks, with lofts located above that are accessed by a central courtyard with stairs and galleries.

Die ehemalige Wartungshalle für Torpedoboote aus den fünfziger Jahren wurde in ein außergewöhnliches Wohngebäude verwandelt. Die beiden unteren Geschosse dienen als Parkdecks, darüber liegen Lofts, die über einen zentralen Hof mit Treppen und Galerien erschlossen werden.

L'ancien entrepôt pour l'entretien de torpilleurs des années cinquante a été transformé en un complexe d'habitations exceptionnel. Les deux étages inférieurs servent de garages, audessus se trouvent des lofs accessibles par l'intermédiaire d'une cour centrale avec escaliers et galeries.

La antigua nave de mantenimiento para lanchas torpederas construida en los años cincuenta se ha transformado en un atípico edificio de viviendas. Las dos plantas inferiores hacen el servicio de aparcamientos. Por encima de ellos están ubicados lofts que comparten un patio interior cerrado a través de escaleras y galerías.

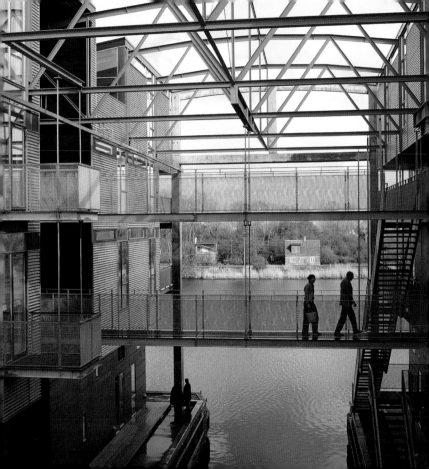

Amerika Pier

3XNielsen A/S

2002
Dampfærgevej 12-16
København Ø

www.nordea-
ejendomsinvestering.dk
www.3xnielsen.dk

By skillful planning of the layouts, all the apartments in the building are directly facing the water. The six penthouse apartments on the top floor are especially privileged. Their roof terraces offer generous open spaces right in the heart of town.

Durch eine geschickte Gliederung der Grundrisse sind alle Wohnungen des Gebäudes direkt zum Wasser hin ausgerichtet. Besonders privilegiert sind die sechs Penthauswohnungen im obersten Geschoss, deren Dachterrassen großzügige Freiräume inmitten der Stadt bieten.

Grâce à une division habile des plans au sol, tous les appartements du bâtiment sont directement tournés vers la mer. Les six appartements penthouses du dernier étage sont particulièrement privilégiés car les terrasses du toit représentent de précieux espaces libres en pleine ville.

La acertada distribución de la planta del edificio hace que todos los pisos estén dirigidos al agua. Los más privilegiados son los seis pisos en el ático, dotados de terrazas que proporcionan amplios espacios abiertos en medio de la ciudad.

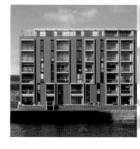

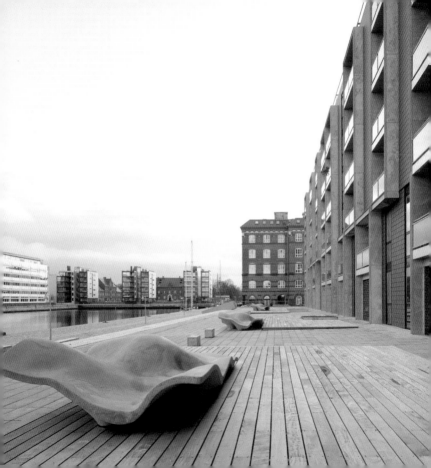

Industri-Kollegiet

LUNDGAARD & TRANBERG ARKITEKTFIRMA A/S
MT Højgaard A/S (SE)

2004
Rådmandsgade 61
København N

www.industrikollegiet.dk
www.lt-ark.dk
www.mthojgaard.dk

The rooms of the student hostel are located in an elongated, narrow building. Towards the street, this shows a rather closed façade; on the garden side, two slim, transparent towers are situated with the communal kitchens and dining areas.

Die Zimmer des Studentenwohnheimes liegen in einem langgestreckten, schmalen Baukörper. Zur Straße hin zeigt dieser eine eher geschlossene Fassade; auf der Gartenseite stehen zwei schlanke, transparente Türme mit den gemeinschaftlich genutzten Küchen und Essbereichen.

Les chambres de cette résidence universitaire se trouvent dans un bâtiment étroit et allongé. Sur la rue, sa façade est plutôt fermée ; mais côté jardin, il y a deux tours minces et transparentes hébergeant les parties communes, cuisines et salles à manger.

Las habitaciones de esta residencia de estudiantes están ubicadas en un cuerpo constructivo alargado y estrecho. La fachada hacia la calle es más bien cerrada. Del lado del jardín están situadas dos esbeltas torres transparentes que albergan cocina y comedores comunes.

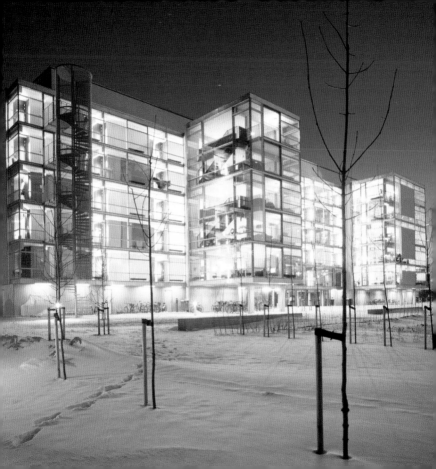

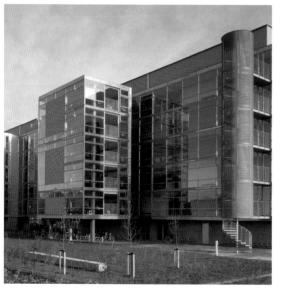

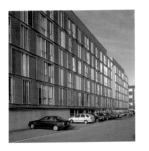

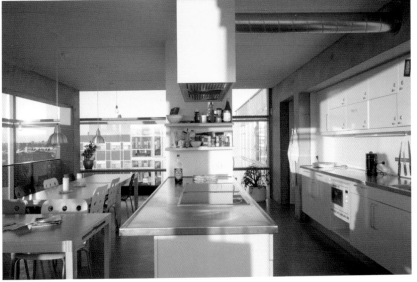

Charlottehaven

LUNDGAARD & TRANBERG ARKITEKTFIRMA A/S
MT Højgaard A/S (SE)
Erik Petersen A/S (SE)

2004
Hjørringgade 12
København Ø

www.charlottehaven.com
www.lt-ark.dk
www.mthojgaard.dk

Dark brick, glass and wooden window fittings: only a few materials influence the character of the residential site, which also includes a café, kindergarten, conference center and fitness club. The apartments in the seven-storey towers are for temporary rentals as guest apartments.

Dunkle Ziegel, Glas und hölzerne Fensterprofile: Nur wenige Materialien prägen den Charakter der Wohnanlage, zu der auch ein Café, ein Kindergarten, ein Konferenzzentrum sowie ein Fitnessclub gehören. Die Apartements in den siebengeschossigen Türmen werden temporär als Gästewohnungen vermietet.

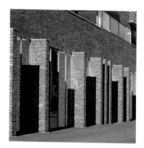

Des briques sombres, du verre et des cadres de fenêtre en bois : ces quelques matériaux caractérisent cet ensemble d'habitations qui comprend également un café, un jardin d'enfants, un centre de conférences et un club de fitness. Les appartements des tours de sept étages sont loués temporairement à des hôtes de passage.

Un conjunto de viviendas al que dan todo el carácter unos pocos materiales: las tejas oscuras, el cristal y los perfiles de ventanas en madera. El lugar alberga además una cafetería, jardín de infancia, un centro de conferencias y un gimnasio. Las torres de siete plantas cuentan con apartamentos que se alquilan de forma temporal.

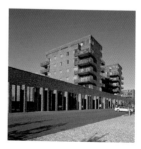

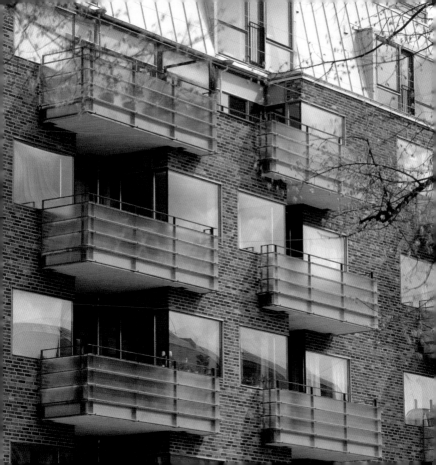

Tuborg Nord

Vilhelm Lauritzen A/S
RAMBØLL Danmark A/S (SE)

1999
Strandvejen 60
Hellerup

www.tuborgnord.dk
www.vla.dk
www.ramboll.dk

The former factory site of Tuborg Brewery is located in the north of Copenhagen. Over a period of several years, a new city district covering over 400,000 m² is being created here with different potential uses. There is an extensive view of Øresund from the residential buildings along the canal.

Im Norden von Kopenhagen liegt das ehemalige Fabrikgelände der Tuborg Brauerei. Auf über 400.000 m² Fläche entsteht hier seit einigen Jahren ein neuer Stadtteil mit unterschiedlichen Nutzungsmöglichkeiten. Von den Wohngebäuden entlang des Kanals genießt man einen weiten Blick auf den Øresund.

Au nord de Copenhague se trouve l'ancien site industriel de la brasserie Tuborg. Depuis quelques années il se construit ici sur plus de 400.000 m² un nouveau quartier avec différentes possibilités d'exploitation. Des bâtiments d'habitation le long du canal, on jouit d'une vue dégagée sur l'Øresund.

Al norte de Copenhague se encuentra la antigua fábrica de cerveza Tuborg. En una superficie que supera los 400.000 m² se ha levantado hace unos años un nuevo barrio de la ciudad con diversas posibilidades de aprovechamiento. Desde los edificios de viviendas y a lo largo del canal se disfruta de una amplia vista a Øresund.

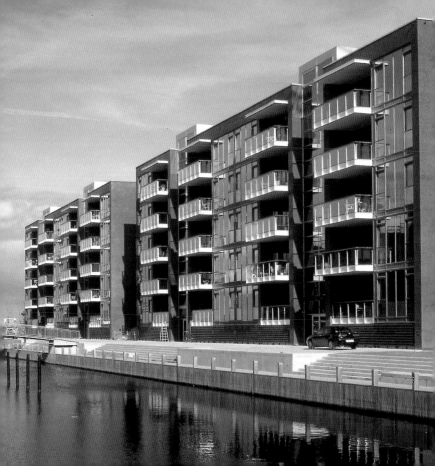

City for all ages

3XNielsen A/S

2007
Valby Langgade 95
Valby

www.3xnielsen.dk

The two-storey lower section of this unusual apartment block contains apartments for seniors and therapy facitilities, but there is also a kindergarten. There are apartments for young families in the ring development, which is also on two levels and located right above.

Der zweigeschossige Sockelbau dieses ungewöhnlichen Wohnblocks enthält Apartements für Senioren und Therapieeinrichtungen, aber auch einen Kindergarten. In der darüberliegenden, ebenfalls zweigeschossigen Ringbebauung befinden sich Wohnungen für junge Familien.

Le bâtiment socle de deux étages de ce bloc d'habitations original comprend des appartements pour les seniors et des installations thérapeutiques mais aussi un jardin d'enfants. Les deux étages construits tout autour au-dessus abritent des appartements pour de jeunes familles.

La construcción de pedestal de dos pisos de este atípico bloque de viviendas alberga apartamentos para personas mayores además de instalaciones para terapias y un jardín de infancia. El edificio circular situado encima, también de dos plantas, contiene viviendas para familias jóvenes.

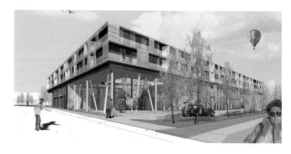

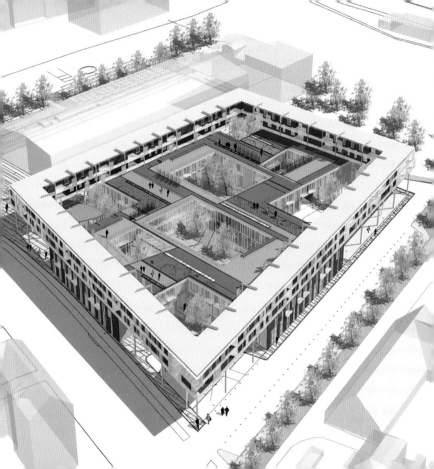

Teglværkshavnen

tegnestuen vandkunsten ApS
Lemming & Eriksson A/S (SE)

2006
Teglholm Allé
København SV

www.vandkunsten.com
www.lemming-eriksson.dk

A new, attractive residential area is currently being created out of an old, industrial harbor. A special idea is that the buildings are meant to stand on stilts right in the old harbor basin and they are to have bridges connecting them to the shore.

Aus einem alten Industriehafen wird gegenwärtig ein neues, attraktives Wohngebiet. Als besonderer Clou sollen die neuen Bauten auf Stützen direkt im ehemaligen Hafenbecken stehen und über Brücken mit dem Ufer verbunden werden.

Ce qui était un vieux port industriel est en train de devenir un nouveau quartier résidentiel séduisant. Le clou du projet est de poser les nouveaux bâtiments sur pilotis directement dans l'ancien bassin portuaire et de les relier par des ponts avec la berge.

Lo que fue un puerto industrial se ha convertido hoy en una atractiva zona residencial. Como idea novedosa se proyectó que los edificios se apoyaran sobre pilotes dentro de la antigua dársena y fueran unidos a la orilla a través de puentes.

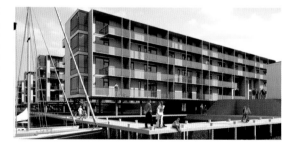

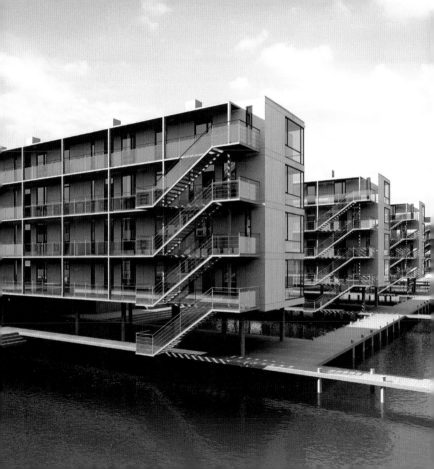

VM Housing

PLOT

2005
Ørestads Boulevard 57-59
København S

www.plot.dk

The building's external form is already very unusual: the structures are both convolving in the layout, so that interesting views and relations of sight lines result. An amazing variety of different types of apartments is on offer in the interior, each with special features and qualities.

Schon die äußere Form der Gebäude ist sehr ungewöhnlich: Beide Baukörper sind im Grundriss gefaltet, so dass sich interessante Ansichten und Blickbeziehungen ergeben. Im Inneren bieten sie eine erstaunliche Vielzahl unterschiedlicher Wohnungstypen mit jeweils speziellen Eigenheiten und Qualitäten.

La forme extérieure des bâtiments est déjà très inhabituelle : les deux bâtiments sont « pliés » sur le plan de base si bien qu'il en résulte des points de vue et des rapports de perspective intéressants. A l'intérieur ils autorisent une étonnante variété de types d'appartements différents avec leurs singularités et qualités propres.

Ya la forma exterior del edificio llama la atención por lo atípica que resulta. Ambos cuerpos constructivos están plegados en la planta, creando de esta manera momentos ópticos y vistas interesantes. El interior alberga una llamativa cantidad de modelos de piso, cada uno con propiedades y cualidades diversas.

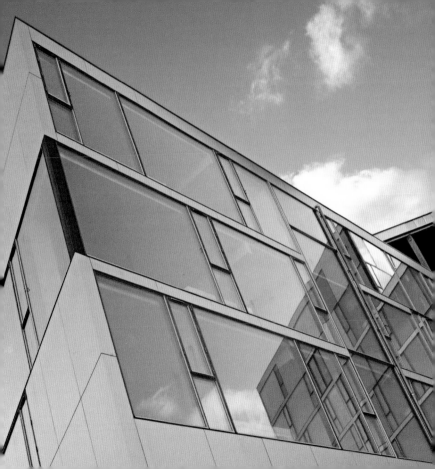

Architects' Building

3XNielsen A/S
RAMBØLL Danmark A/S (SE)

1996
Strandgade 27
København K

www.arkitektforeningen.dk
www.3xnielsen.dk
www.ramboll.dk

The building consists of two parts: a concrete cube, which is used by the Danish Foreign Ministry; and a building made out of wood, which houses the national society of architects. The narrow space between both building parts contains stairs, elevators and connecting bridges and is meant to be reminiscent of a ship's body in dock.

Das Gebäude besteht aus zwei Teilen: Einem Betonkubus, der durch das Dänische Außenministerium genutzt wird und einem Baukörper aus Holz, in dem der nationale Architektenverband residiert. Der schmale Raum zwischen den beiden Gebäudeteilen enthält Treppen, Aufzüge und Verbindungsbrücken und soll an einen Schiffsrumpf im Dock erinnern.

Le bâtiment est constitué de deux parties : un cube en béton d'une part, occupé par le Ministère danois des Affaires Etrangères et un corps en bois d'autre part, hébergeant la Fédération nationale des Architectes. L'espace étroit entre les deux parties abrite escaliers, ascenseurs et ponts de connexion ; il est censé rappeler la coque d'un bateau à quai.

El edificio consta de dos partes: un cubo de hormigón del que hace uso el Ministerio de Asuntos Exteriores de Dinamarca, y otro de madera que alberga el colegio de arquitectos. El estrecho espacio entre ambos contiene escaleras, ascensores y puentes de enlace y asemeja a un casco de barco en el muelle.

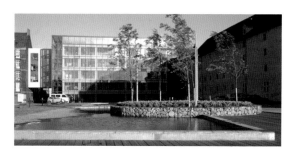

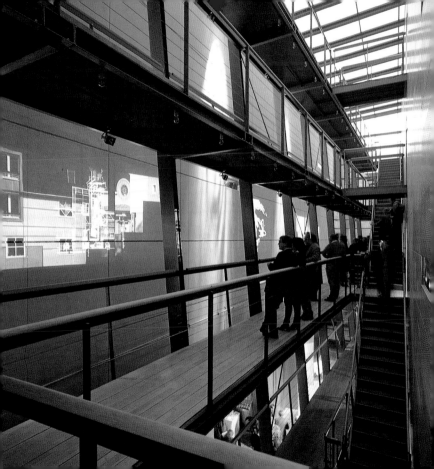

Nordea

HLT HENNING LARSENS TEGNESTUE A/S

1999
Strandgade 3
København K

www.hlt.dk

The Nordea buildings are exemplary for the typical characteristics of Danish architecture: discipline, simplicity and elegance. Four buildings, which are clad in dark copper metal, are facing the water. The entrance courtyard for the entire facility is surrounded by a U-shaped building section, which is clad in sandstone.

Die Nordea-Gebäude stehen beispielhaft für die typischen Merkmale der dänischen Architektur: Strenge, Einfachheit und Eleganz. Vier mit dunklem Kupferblech verkleidete Baukörper sind zum Wasser hin ausgerichtet. Ein U-förmiger, mit Sandstein verkleideter Gebäudeteil umschließt den Eingangshof der Gesamtanlage.

Les immeubles Nordea réunissent de façon exemplaire toutes les caractéristiques de l'architecture danoise : austérité, simplicité et élégance. Quatre bâtiments habillés de tôle de cuivre sombre sont axés vers l'eau. Un corps de bâtiment en U revêtu de grès enserre la cour d'entrée du complexe.

Los edificios Nordea son un claro ejemplo de las características típicas de la arquitectura danesa: vigor, simplicidad y elegancia. Las cuatro estructuras revestidas de chapa de cobre están ubicadas en dirección al agua. Una parte de edificio en forma de U construida con piedra arenisca cierra el patio de entrada del recinto.

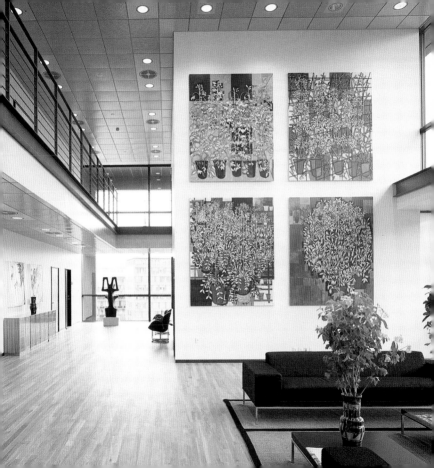

FIH Erhvervsbank

3XNielsen A/S

Langelinie Allé 43
København Ø

www.fih.dk
www.3xnielsen.dk

Mobile sun-screens out of aluminum rotate—according to the fall of the light—either in front of the windows or walls of the office block. In this way, the façade's appearance is subject to constant change. A light installation inside the open staircase reacts to the ascending and descending movements of the elevators.

Bewegliche Sonnenschutzelemente aus Aluminium schieben sich – je nach Lichteinfall – entweder vor die Fenster oder vor die Wandfelder des Bürohauses. Das Fassadenbild ist dadurch einem ständigen Wandel unterworfen. Ein Lichtkunstwerk innerhalb des offenen Treppenhauses reagiert auf die Auf- und Abwärtsbewegungen der Fahrstühle.

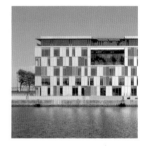

Des volets orientables en aluminium coulissent – selon l'incidence de la lumière – soit devant les fenêtres soit devant la partie de mur du bâtiment administratif. L'aspect de la façade est donc en perpétuelle mutation. A l'intérieur de la cage d'escalier ouverte, une sculpture de lumière réagit aux montées et descentes des ascenseurs.

Una serie de elementos móviles de protección solar de aluminio se deslizan, según la incidencia de la luz, por delante de la ventana o en las paredes del edificio de oficinas. De esta forma la fachada está sometida a un cambio constante. En el interior de la escalera abierta se forma un juego de luz que reacciona a los movimientos de ascenso y descenso de los ascensores.

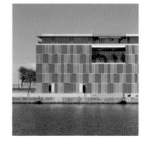

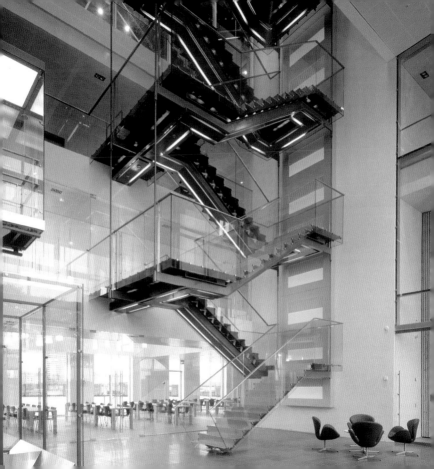

Sonofon Headquarters

DISSING+WEITLING arkitektfirma A/S
Højgaard & Schultz A/S (SE)

1999
Frederikskaj 8
København SV

www.dw.dk

The five-storey building rests on a rectangular layout: two office wings are located opposite each other and form an interior courtyard that opens towards the water. The auditorium and canteen are also located in this intermediate area. A radio mast is also fixed on the striking apex of the triangle—which is appropriate for a telecommunications company.

Ce bâtiment de cinq étages repose sur un tracé triangulaire : deux ailes de bureaux se font face et forment une cour intérieure s'ouvrant sur l'eau. Dans cet espace intermédiaire se trouvent également l'amphithéâtre et la cantine. A l'angle aigu du triangle se dresse une antenne – emblème très approprié pour un opérateur mobile.

Das fünfgeschossige Gebäude beruht auf einem dreieckigen Grundriss: Zwei Büroflügel liegen sich gegenüber und bilden einen sich zum Wasser hin öffnenden Innenhof. In diesem Zwischenbereich liegen auch das Auditorium und die Kantine. Auf der markanten Spitze des Dreiecks sitzt – passend für ein Telekommunikations-Unternehmen – eine Antenne.

El edificio de cinco pisos se apoya en una planta triangular. Las dos alas de oficinas se sitúan una enfrente de la otra formando un patio interior abierto dirigido al agua. En este espacio intermedio se ubican el comedor y el auditorio. Como es de esperar en un edificio de una empresa de telecomunicaciones, en el llamativo extremo de esta estructura triangular se ha instalado una antena.

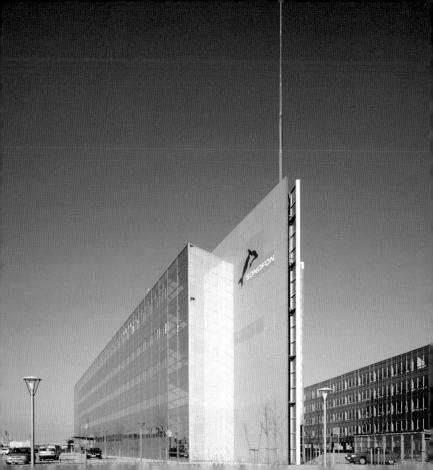

Daimler Chrysler

DISSING+WEITLING arkitektfirma A/S
Højgaard & Schultz A/S (SE)

1999
Frederikskaj 4
København SV

www.dw.dk

While the façades of Daimler Chrysler's administrative center appear rather strict with tinted glass windows and dark, granite sections, the offices are kept in light, friendly colours and wood tones. The foyer is dominated by an elegant stairway.

Während die Fassaden der Verwaltung von Daimler Chrysler mit den getönten Glasscheiben und den dunklen Granitplatten eher streng wirken, sind die Büros in hellen, freundlichen Farben und Holztönen gehalten. Das Foyer wird von einer eleganten Treppe beherrscht.

Tandis que les façades de l'administration de Daimler Chrysler paraissent plutôt sévères avec leurs vitres teintées et les plaques de granit sombres, les bureaux privilégient des tons de bois et des couleurs claires et agréables. Le hall d'entrée est marqué par la plastique de l'escalier.

Si bien la fachada de las oficinas administrativas de Daimler Chrysler con vidrios tintados y planchas de granito da una imagen de rigidez, el interior de las oficinas tiene tonos de madera y colores claros y alegres. El vestíbulo está dominado por una elegante escalera.

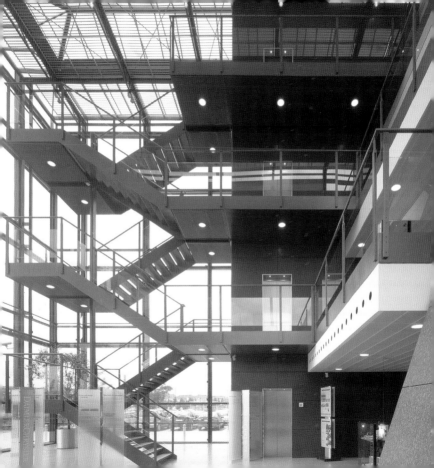

Sampension

3XNielsen A/S
RAMBØLL Danmark A/S (SE)

2003
Tuborg Havnevej 14
Hellerup

www.kp.dk
www.3xnielsen.dk
www.ramboll.dk

Two different materials—perforated copper panels and grey-green granite plates—defined the exterior of the insurance building in Tuborg Syd. In the interior, an elliptical atrium with its rolling flights of stairs is a striking feature. A water and light installation also appeals to the senses.

Zwei unterschiedliche Materialien – gelochte Kupferpaneele und graugrüne Granitplatten – bestimmen das Äußere des Versicherungsgebäudes in Tuborg Syd. Bestechend ist im Inneren ein elliptisches Atrium mit seinen geschwungenen Treppenläufen. Eine Wasser- und Lichtinstallation spricht zusätzlich die Sinne an.

Deux types de matériaux – des panneaux de cuivre perforés et des plaques de granit gris-vert – déterminent l'aspect extérieur de l'immeuble d'une compagnie d'assurances à Tuborg Syd. A l'intérieur c'est un atrium elliptique qui éblouit avec ses développés d'escalier hardis. Une installation de jeux d'eau et de lumière éveille d'agréables sensations.

El exterior del edificio de seguros en Tuborg Syd se ha creado con dos materiales diferentes: paneles de cobre perforado y placas de granito gris verdoso. En el interior resalta el atrio elíptico de escaleras onduladas. A ello se suma una instalación de luz y agua que despierta los sentidos.

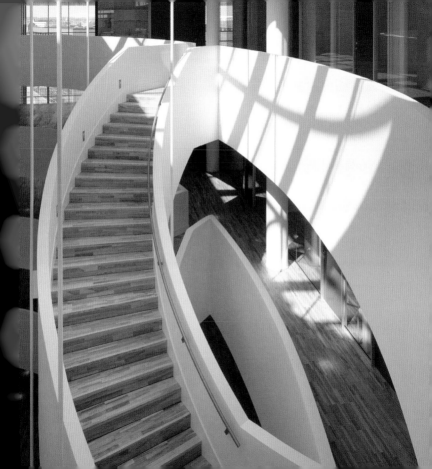

Ferring International Center

HLT HENNING LARSENS TEGNESTUE A/S
Moe & Brødsgaard (SE)

2001
Kay Fiskers Plads 11
København S

www.ferring.com
www.hlt.dk
www.moe.dk

The strict, almost dismissive-looking building houses the administration as well as research and development department of a pharmaceutical company. The laboratories are located in a flat, low building. The high-rise block for the administration with a total of twenty floors is regarded as one of Scandinavia's tallest buildings.

Das strenge, fast schroff wirkende Gebäude beherbergt die Verwaltung sowie die Forschungs- und Entwicklungsabteilung eines Pharmakonzerns. Die Labore sind in einem flachen Sockelbau untergebracht. Das insgesamt zwanziggeschossige Hochhaus für die Verwaltung gilt als eines der höchsten Gebäude Skandinaviens.

Cet immeuble d'apparence sévère voire abrupte abrite l'administration et les départements Recherche et Développement d'une entreprise pharmaceutique. Les laboratoires occupent un bâtiment socle plat. Le building qui compte vingt étages est utilisé par l'administration ; il s'agit de l'une des plus hautes tours en Scandinavie.

Este edificio de aspecto rígido y escarpado alberga la administración y el departamento de investigación y desarrollo de una industria farmacéutica. Los laboratorios se encuentran en el interior de una construcción de pedestal plana. Con sus veinte plantas, se trata de uno de los edificios más altos de Escandinavia.

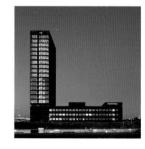

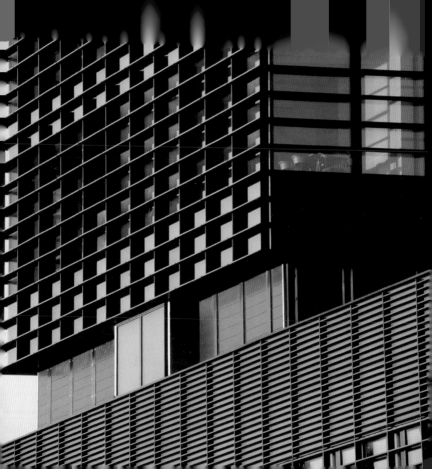

Weishaupt

Nøhr & Sigsgaard Arkitektfirma A/S

2002
Erhvervsvej 10
Glostrup

www.weishaupt.dk
www.nsark.dk

The subsidiary of a German company was extended with a two-storey showroom. It also contains a central conference room, which was suspended from the ceiling by thin, steel supports. The interior rooms are characterized by great care in the design of details as well as light, friendly surfaces.

Die Niederlassung eines deutschen Unternehmens wurde um einen zweigeschossigen Showroom erweitert. Darin befindet sich auch ein zentraler Besprechungsraum, der mit dünnen Stahlträgern von der Decke abgehängt wurde. Die Innenräume zeichnen sich durch eine sorgfältige Detaillierung sowie helle, freundliche Oberflächen aus.

La succursale d'une entreprise allemande s'est vu adjoindre un showroom de deux étages. Celui-ci comprend aussi une salle de réunion centrale, suspendue au plafond à l'aide de poutrelles métalliques. Les pièces intérieures se distinguent par le grand soin apporté à l'élaboration des détails et par des surfaces claires et agréables.

La sede de una empresa alemana fue ampliada con una sala de exposiciones de dos plantas. En ella se encuentra además una sala de reuniones central pendiente del techo a través de dos vigas de acero. Los interiores se caracterizan por el cuidado a la hora de concebir los detalles, así como por las superficies luminosas y vivas.

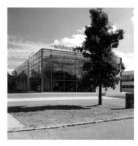

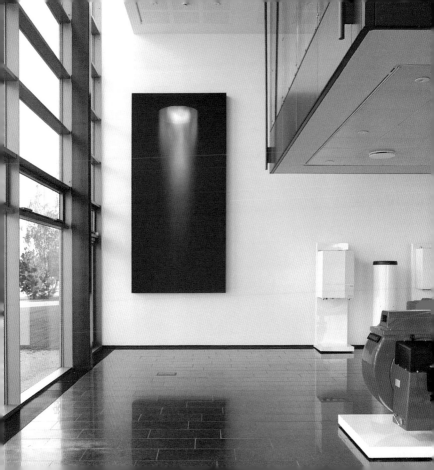

Realkredit Danmark

Vilhelm Lauritzen A/S
Rasmussen & Schiøtz A/S (SE)

1998
Køgevej 54
Taastrup

www.vla.dk

Uniform ceilings, floors and partition wall systems were developed for the new design concept of the subsidiaries of a Danish bank. Uniform models were also designed for the furnishing in the branches—bank counters, shelves and tables.

Für das neue Designkonzept der Zweigstellen einer dänischen Bank wurden gleichartige Decken, Böden und Trennwandsysteme entwickelt. Auch für die Möblierung der Filialen – Bankschalter, Regale und Tische – wurden einheitliche Modelle entworfen.

Pour le nouveau concept de design des filiales d'une banque danoise, des plafonds, des sols et des systèmes de cloisons identiques ont été élaborés. De même, pour l'ameublement des filiales – guichets, étagères et tables – des modèles unitaires ont été conçus.

Para el proyecto de diseño de la filial de este banco danés se desarrollaron techos, suelos y sistemas de separación de tabiques, todos ellos semejantes. El mobiliario de las filiales, mostradores, estanterías y mesas han sido también concebidos en un estilo uniforme.

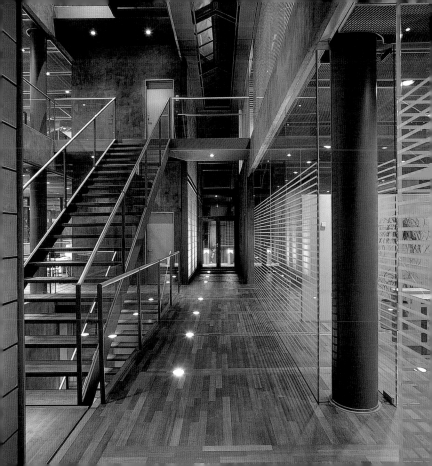

Danish Jewish Museum

Studio Daniel Libeskind

2003
Proviantpassagen 6
København K

www.jewmus.dk
www.daniel-libeskind.com

The expressive exhibition architecture is in contrast to the simple vaults of the museum, a brick building dating from the early 17th century. The overlapping of different forms, structures and materials creates an exciting dialogue between past and present.

Die expressive Ausstellungsarchitektur steht in Kontrast zu den schlichten Tonnengewölben des Museums, einem Backsteinbau aus dem frühen 17. Jahrhundert. Die Überlagerung der unterschiedlichen Formen, Strukturen und Materialien schafft einen spannungsvollen Dialog zwischen Vergangenheit und Gegenwart.

L'architecture de l'exposition très expressive contraste avec les voûtes en berceau dépouillées du musée, un bâtiment de brique datant du début du 17ème siècle. La superposition des différentes formes, structures et matériaux permet d'établir un dialogue dynamique entre le passé et le présent.

La expresiva arquitectura de las exposiciones contrasta con la austera bóveda de cañón del museo, una construcción de ladrillo del siglo XVII. La superposición de las diversas formas, estructuras y materiales crea un palpitante diálogo entre presente y pasado.

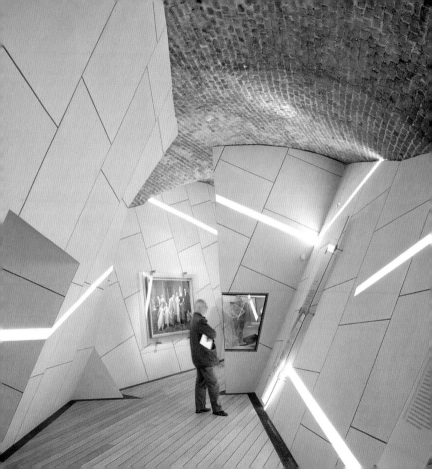

Skuespilhus

LUNDGAARD & TRANBERG ARKITEKTFIRMA A/S

2008
Kvæsthusbroen
København K

www.skuespilhus.dk
www.lt-ark.dk

The striking stage tower soars above the horizontally structured building. In addition to the large auditorium for an audience of 750, the new theater will also provide room for a smaller, flexible stage as well as a rehearsal stage. All three halls are accessed by a spacious foyer that faces the harbor.

Der markante Bühnenturm ragt aus dem horizontal gegliederten Bau hervor. Neben dem großen Saal für 750 Zuschauer wird das neue Theater auch einer kleineren, flexiblen Bühne sowie einer Probebühne Platz bieten. Alle drei Säle werden durch ein großzügiges, dem Hafen zugewandtes Foyer erschlossen.

Une tour carrée correspondant à la scène émerge du plateau horizontal du bâtiment. Outre la grande salle accueillant 750 spectateurs, le nouveau théâtre comportera une scène plus petite et modulable ainsi qu'une scène pour les répétitions. Les trois salles sont distribuées autour d'un hall spacieux tourné vers le port.

La llamativa torre del escenario sobresale del edificio de estructura horizontal. Además de tener una gran sala que da cabida a 750 espectadores el teatro cuenta con un escenario algo más reducido y flexible, así como con uno para ensayos. Las tres salas están unidas por un vasto vestíbulo orientado al puerto.

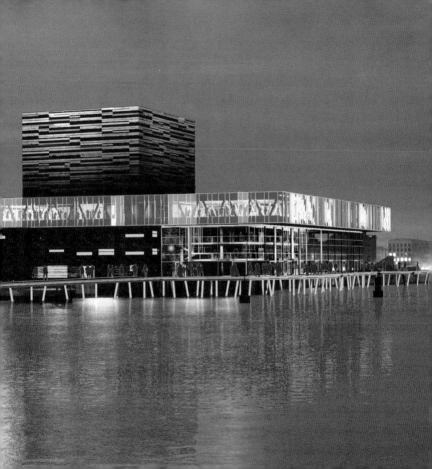

Operaen
The Copenhagen Opera House

HLT HENNING LARSENS TEGNESTUE A/S
RAMBØLL Danmark A/S (SE)

2004
Ekvipagemestervej 10
København K

www.operahus.dk
www.hlt.dk
www.ramboll.dk

The new opera house is located on a privileged spot in the city's layout,—right next to the Frederikskirken and Amalienborg Castle. The massive building was privately financed by a Danish shipping magnate. In summer, open-air performances are meant to take place on a floating stage under the enormous roof covering.

Das neue Opernhaus liegt an einer privilegierten Stelle im Stadtgrundriss, direkt gegenüber der Frederikskirken und dem Schloss Amalienborg. Der gewaltige Bau wurde von einem dänischen Reeder privat finanziert. Unter der riesigen Dachfläche sollen im Sommer auf einer schwimmenden Bühne Open-Air Aufführungen stattfinden.

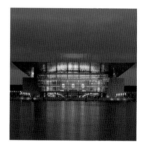

Le nouvel opéra occupe un emplacement privilégié au cœur de la ville, directement en face de la Frederikskirken et du château Amalienborg. Cet édifice imposant a été financé par les fonds privés d'un armateur danois. En été, sous l'immense toiture, auront lieu des représentations en plein air sur une scène flottante.

La nueva ópera está ubicada en uno de los espacios privilegiados de la ciudad, justo enfrente de la Frederikskirken y del palacio de Amalienborg. Esta gran construcción ha sido financiada por una empresa naviera danesa. Bajo las enormes áreas del tejado está proyectado que en verano se lleven a cabo representaciones Open-Air sobre un escenario flotante.

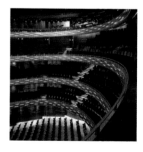

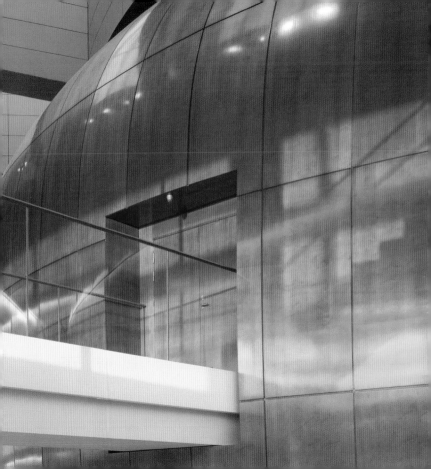

Arbejdermuseet
The Workers' Museum

LUNDGAARD & TRANBERG ARKITEKTFIRMA A/S
Jørgen Nielsen A/S (SE)

2004
Rømersgade 22
København K

www.arbejdermuseet.dk
www.lt-ark.dk

The extension of The Workers' Museum demanded special sensitivity from the architects: the museum is located in the city center in a heavily built-up, listed-building block. There was actually no more space for additional buildings. The new exhibition halls are therefore located underground; and the building sections above ground were restricted to a minimum.

L'extension du Musée des Travailleurs a requis des architectes beaucoup de doigté : le musée se situe dans un pâté de maisons du centre ville, classé monument historique, où la construction est dense ; en fait il n'y avait plus de place pour d'autres bâtiments. Les nouvelles surfaces d'exposition sont donc en sous-sol, les parties en surface ayant été limitées au maximum.

Die Erweiterung des Arbeitermuseums erforderte von den Architekten besondere Sensibilität: Das Museum liegt in einem denkmalgeschützten, dicht bebauten Block im Stadtzentrum; für zusätzliche Bauten war eigentlich kein Platz mehr. Die neuen Ausstellungsflächen liegen darum unter der Erde, die oberirdischen Gebäudeteile wurden auf ein Minimum beschränkt.

La ampliación del Museo del Trabajo implicó una especial sensibilidad por parte de sus arquitectos. El museo está ubicado en un barrio muy compacto del centro de la ciudad, considerado patrimonio nacional, y en realidad no se disponía de espacio para un edificio adicional. De ahí que las nuevas salas de exposiciones se encuentren bajo tierra y las partes superiores del edificio se hayan reducido al mínimo.

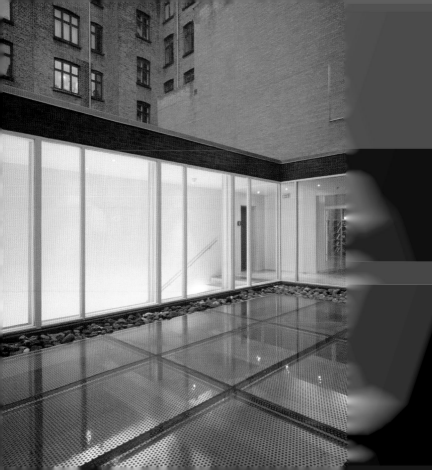

GBIF - Global Biodiversity Information Facility

KHR Arkitekter A/S
Erik K. Jørgensen A/S (SE)

2003
Universitetsparken 15
København Ø

www.gbif.org
www.khr.dk
www.ekj.dk

The Institute collects data on the global diversity of species and makes the information available worldwide. The architects therefore interpret the registry office as a kind of "computer server", whose bright red façade seems to be sqeezed in between an existing museum building and an access tower.

Das Institut sammelt Daten zur globalen Artenvielfalt und macht diese Informationen weltweit zugänglich. Die Architekten interpretierten das Sekretariatsgebäude darum als eine Art großen „Computer-Server", der mit seiner leuchtend roten Fassade zwischen einem vorhandenen Museumsbau und einem Erschließungsturm zu klemmen scheint.

L'institut collecte des données sur la biodiversité globale et rend ces informations accessibles dans le monde entier. Les architectes ont donc représenté le bâtiment du secrétariat en gros « serveur informatique » qui a l'air coincé, avec sa façade rouge lumineuse, entre un musée déjà existant et une tour de désenclavement.

El instituto recopila datos sobre la diversidad de las especies y los distribuye por todo el mundo. Los arquitectos han interpretado el edificio de secretaría como una especie de servidor informático, de fachada luminosa roja que parece estar pillado entre la estructura del museo ya existente y la torre de desarrollo.

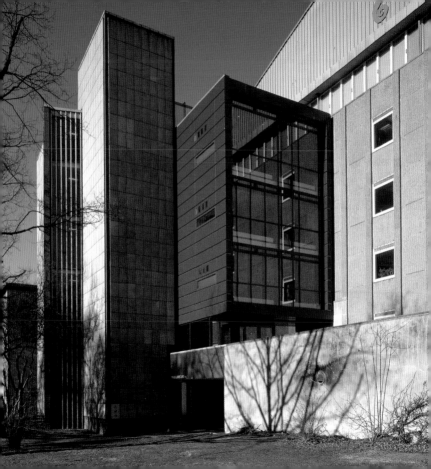

KVL Den Kgl. Veterinær- og Landbohøjskole

The Royal Veterinary and Agricutural University, Denmark

Erik Møllers Tegnestue A/S
Moe & Brødsgaard (SE)

2001
Ridebanevej
Frederiksberg C

www.kvl.dk
www.emt.dk
www.moe.dk

In addition to the anatomical lecture theater with its typical semicircular shape, other teaching and research facilities for veterinary scientists are located in the building. The interior of the lecture theater is defined by stainless steel surfaces—not just for aesthetic reasons, but also because of hygiene.

Neben dem Anatomischen Hörsaal mit seiner typischen halbrunden Form sind in dem Gebäude weitere Lehr- und Forschungseinrichtungen für Veterinärwissenschaftler untergebracht. Die Einrichtung des Hörsaals wird von Edelstahloberflächen bestimmt – allerdings nicht nur aus ästhetischen, sondern auch aus hygienischen Gründen.

A côté de l'amphithéâtre d'anatomie, un demi-cercle typique, il y a dans le bâtiment d'autres installations pour l'enseignement et la recherche destinées aux vétérinaires. Dans l'aménagement de l'amphithéâtre prédominent des surfaces en inox – moins toutefois pour l'esthétique que pour des raisons d'hygiène.

Junto al aula principal de anatomía con su típica forma semicircular se han construido otros espacios para enseñanza e investigación sobre veterinaria. Para la instalación del aula principal se ha optado por las superficies de acero inoxidable, no sólo por estética sino al mismo tiempo por razones de higiene.

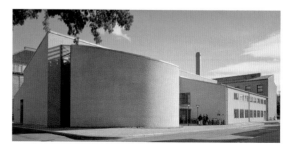

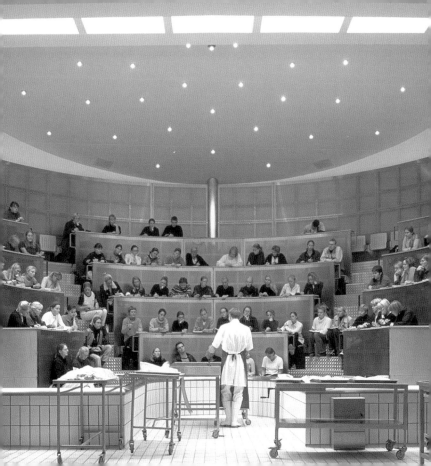

Svanemøllens Kaserne
The Royal Defence Academy

Entasis A/S – Christian Cold

2002
Ryvangs Allé 1
København Ø

www.entasis.dk

The façades of the relatively small lecture theater are influenced by local concrete and slate. The thickness of the slate sections varies by up to 10 millimeters, so that a lively façade image is created with slight projections and recesses. In the building's interior, there are simple materials such as wood and concrete, which were nevertheless treated extremely carefully.

Die Fassaden des relativ kleinen Hörsaalgebäudes sind durch Ortbeton und Schiefer geprägt. Die Dicke der Schiefertafeln variiert um bis zu 10 mm, so dass durch leichte Vor- und Rücksprünge ein lebendiges Fassadenbild entsteht. Im Inneren des Gebäudes finden sich einfache Materialien wie Holz und Beton, die jedoch äußerst sorgfältig verarbeitet wurden.

Les façades de ce bâtiment de salles de cours assez petit sont marquées par du béton coulé sur place et de l'ardoise. L'épaisseur des plaques d'ardoise varie jusqu'à 10 mm si bien la façade s'anime grâce à ces légers retraits et avancées. A l'intérieur, les matériaux employés, bois et béton, sont simples mais travaillés avec le plus grand soin.

La fachada de este edificio de aulas relativamente pequeño se caracteriza por el hormigón preparado en el sitio y la pizarra. El espesor de las planchas de pizarra puede variar hasta unos 10 mm, lo que acompañado de los ligeros entrantes y salientes crea un cuadro de fachada viviente. Para el interior del edificio se ha optado por materiales sencillos como el hormigón y la madera, que sin embargo han sido procesados cuidadosamente.

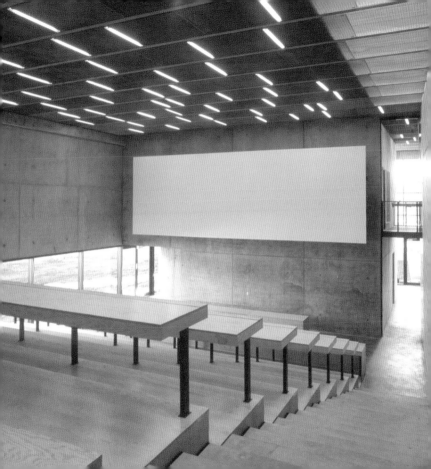

IT University

HLT HENNING LARSENS TEGNESTUE A/S

2004
Rued Langgaards Vej 7
København S

www.itu.dk
www.hlt.dk

The buildings of the IT University are strictly arranged in a north-south direction. Two buildings were connected by a large roof. A great hall was created in between, where boxes extend into the space by freely projecting into it. This area is available for conferences and team work.

Die Gebäude der IT-Universität sind streng in Nord-Süd-Richtung orientiert. Zwei Baukörper wurden mit einem großen Dach verbunden. Dazwischen entstand eine große Halle, in die frei auskragende Boxen ragen. Diese bieten Platz für Besprechungen und gemeinschaftliches Arbeiten.

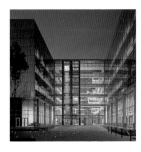

Les bâtiments de l'Université des Technologies de l'Information sont bien orientés en direction nord-sud. Deux corps ont été reliés par une grande toiture. Entre les deux s'est formée une grande halle où dépassent des box en saillie, utilisés pour des réunions et des travaux en commun.

Los edificios de la universidad IT están exactamente orientados en dirección Norte-Sur. Los dos cuerpos se unieron con un gran tejado creando un espacio de grandes dimensiones entre ambos, en el que sobresalen estructuras en forma de cajón; éstas sirven de salas de reuniones y de trabajo en grupo.

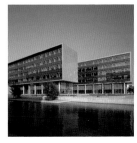

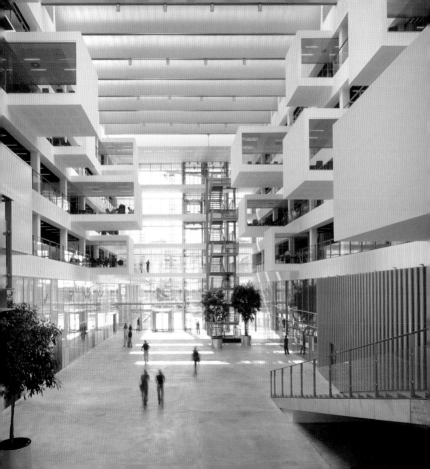

DR Byen

Vilhelm Lauritzen A/S
Carl Bro Gruppen (SE)

2005
Ørestadboulevard 19
København S

www.dr.dk/drbyen
www.vla.dk
www.carlbro.dk

The massive building complex of the Danish radio and television network in Ørestad consists of four building sections, which were each designed by different architects. The Vilhelm Lauritzen studio won the competition for the master plan of the overall ensemble and it was also commissioned to plan the first building section.

Der gewaltige Gebäudekomplex der Dänischen Rundfunk- und Fernsehanstalt in Ørestad besteht aus vier Bauabschnitten, die von jeweils unterschiedlichen Architekten gestaltet werden. Den Wettbewerb für den Masterplan des Gesamtensembles hatte das Büro Vilhelm Lauritzen gewonnen, das auch mit der Planung des ersten Bauabschnitts beauftragt wurde.

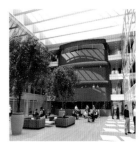

L'énorme complexe immobilier de la Radio et Télévision danoise à Ørestad comprend quatre segments qui ont été conçus par différentes équipes d'architectes. Le bureau Vilhelm Lauritzen, vainqueur du concours pour le plan maître de l'ensemble du projet, s'est vu confié la réalisation du premier segment.

El sobrio grupo de edificios de Ørestad que componen la radio y televisión danesas está formado por cuatro secciones de construcción diseñadas por diferentes arquitectos. El estudio de arquitectos Vilhelm Lauritzen fue quien ganó el concurso al mejor proyecto de edificación del complejo y quien recibió el encargo para realizar la primera sección.

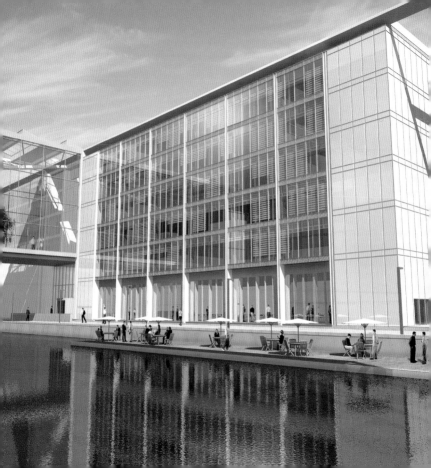

DR Byen Concert Hall

Ateliers Jean Nouvel
Terrell International Ltd. (SE)
NIRAS A/S (SE)

2007
Ørestadboulevard 19
København S

www.jeannouvel.com
www.terrellinternational.co.uk
www.niras.dk

The spectacular concert hall for an audience of 1,600 forms the second building section of the new facility. The real hall seems to be suspended as a wooden-clad sculpture in a massive, square box. At night, the external covering is used as a "screen" for light effects and projections.

Die spektakuläre Konzerthalle für 1.600 Zuhörer bildet den zweiten Bauabschnitt der neuen Anlage. Der eigentliche Saal scheint als holzverkleidete Skulptur in einer riesigen, rechtwinkligen Box zu schweben. Bei Nacht wird die äußere Hülle zum „Screen" für Lichteffekte und Projektionen.

La salle de concert spectaculaire de 1.600 places constitue le deuxième segment du nouveau complexe. La salle, telle une sculpture revêtue de bois, semble flotter dans un immense écrin rectangulaire. La nuit, l'enveloppe extérieure fait fonction d'écran géant pour des jeux de lumières et des projections.

Esta espectacular sala de conciertos para 1.600 espectadores es la segunda sección de la nueva instalación. La sala en sí se presenta como una escultura flotante revestida de madera en el interior de un enorme cajón rectangular. Por la noche la carcasa exterior hace la función de gran pantalla para realizaciones de efectos de luz y proyecciones.

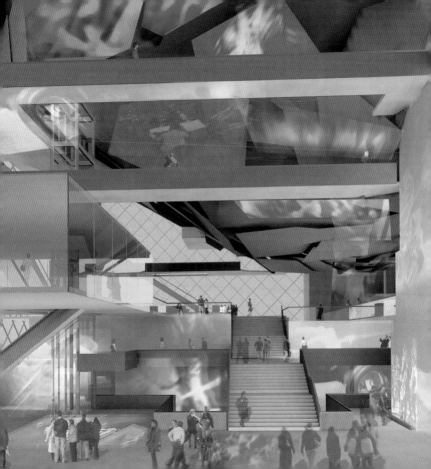

Østrigsgades Skole

Nøhr & Sigsgaard Arkitektfirma A/S

2001
Østrigsgade 14
København S

www.nsark.dk

The remodeling of the former sports' hall into a library with multi-media work stations was part of the renovation and extension of the traditional school building. The modern fittings of steel and glass harmonize with the traditional forms of the historical space.

Zur Sanierung und Erweiterung des traditionsreichen Schulhauses gehörte auch der Umbau der früheren Sporthalle zu einer Bibliothek mit Multi-Media-Arbeitsplätzen. Die modernen Einbauten aus Stahl und Glas harmonieren mit den traditionellen Formen des historischen Raumes.

La rénovation et l'extension de cette école riche en traditions prévoyaient aussi la transformation de l'ancien gymnase en bibliothèque équipée de terminaux multimédias. Les constructions modernes d'acier et de verre sont en harmonie avec les formes traditionnelles de cet espace historique.

Dentro del proyecto de saneamiento y ampliación de esta escuela con tradición, estaba incluida la reestructuración del antiguo polideportivo, que fue transformado en una biblioteca con espacios de trabajo multimedia. Los modernos edificios en acero y vidrio armonizan con las formas tradicionales del edificio histórico.

Ørestad Gymnasium

3XNielsen A/S
Søren Jensen A/S (SE)

2006
Ørestad Boulevard /
Arne Jacobsens Allé
København S

www.3xnielsen.dk
www.sj.dk

A school of a quite special kind: open, flexible learning and working levels are grouped on four floors around a large atrium. The architecture of the grammar school expresses a new lesson idea, which gives priority to free and interdisciplinary learning.

Eine Schule ganz anderer Art: Offene, flexible Lern- und Arbeitsebenen gruppieren sich auf vier Ebenen um ein großes Atrium. Die Architektur des Gymnasiums ist architektonischer Ausdruck eines neuen Unterrichtskonzepts, bei dem freies und interdisziplinäres Lernen im Vordergrund stehen.

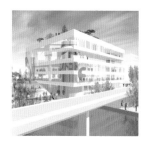

Une école d'un tout autre genre: des niveaux de travail et d'apprentissage ouverts et flexibles sont groupés autour d'un atrium sur quatre étages. L'architecture de ce lycée concrétise un nouveau concept d'enseignement privilégiant un apprentissage libre et interdisciplinaire.

Se trata de una escuela de un estilo completamente diferente. Una serie de espacios de estudio y trabajo abiertos y flexibles están agrupados en cuatro niveles en torno a un atrio. La arquitectura de este instituto es verdadera expresión de un nuevo concepto de aprendizaje, cuyo peso recae en la idea del estudio libre e interdisciplinario.

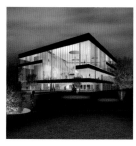

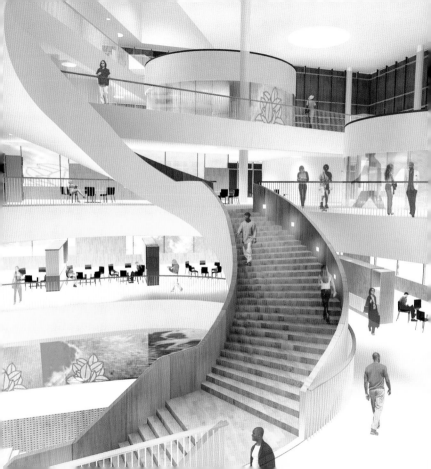

Ordrupgaard Museum
Extension

Zaha Hadid Architects
Jane Wernick Associates (SE)
Birch & Krogboe A/S (SE)

2005
Vilvordevej 110
Charlottenlund

www.ordrupgaard.dk
www.zaha-hadid.com
www.wernick.eu.com
www.birch-krogboe.dk

The exhibition space of the private art collection has almost doubled because of the new extension. The complex composition made out of rolling strips was built with a great deal of technical sophistication to build the concrete structure on site.

Durch den neuen Erweiterungsbau haben sich die Ausstellungsflächen der privaten Kunstsammlung nahezu verdoppelt. Die anspruchsvolle Komposition aus geschwungenen Bändern wurde mit hohem bautechnischen Aufwand vor Ort in Beton gegossen.

Grâce à la nouvelle extension, les surfaces d'exposition de la collection privée ont presque doublé. La composition sophistiquée, faite de sinueux rubans, a requis d'énormes moyens techniques et a été coulée dans le béton sur place.

Gracias a la ampliación, las superficies expositoras de esta colección de arte particular prácticamente se han duplicado. La exigente composición de bandas curvas de hormigón se ha vertido in situ por medio de un enorme aparato técnico.

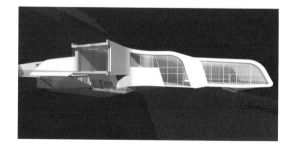

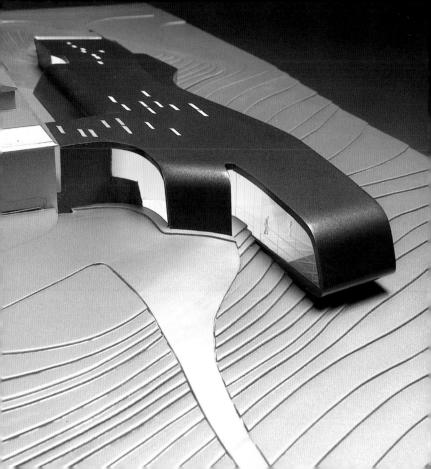

DANCHIP

Erik Møllers Tegnestue A/S
Birch & Krogboe A/S (SE)

2004
Ørsteds Plads
Kgs. Lyngby

www.danchip.dtu.dk
www.emt.dk
www.birch-krogboe.dk

The research center for nano-technology and micro-electronics of the Technical University contains special working facilities and laboratories. Illuminated fields in various colors were integrated into the façade, made out of steel panels and based on a design by the artist, Viera Collaro.

Das Forschungszentrum für Nano-Technologie und Mikro-Elektronik der Technischen Universität enthält spezielle Arbeitsräume und Labore. In die Fassade aus Stahlpaneelen wurden nach einem Konzept der Künstlerin Viera Collaro verschiedenefarbig leuchtende Felder integriert.

Le centre de recherche pour la nanotechnologie et la microélectronique de l'université technique contient des salles de travail et des laboratoires spéciaux. La façade constituée de panneaux d'acier incorpore des panneaux lumineux de différentes couleurs élaborés par l'artiste Viera Collaro.

El centro de investigación de nano y micro tecnología de la universidad técnica alberga salas especializadas de trabajo y laboratorios. En la fachada de paneles de acero se han integrado secciones iluminadas en diversos colores concebidas por la artista Viera Collaro.

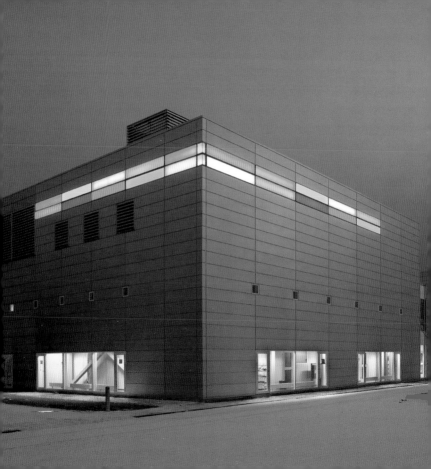

Technical University of Denmark Building 302

Erik Møllers Tegnestue A/S
Birch & Krogboe A/S (SE)

2003
Matematiktorvet
Kgs. Lyngby

www.dtu.dk
www.emt.dk
www.birch-krogboe.dk

The characteristic feature of the small high school building is a roof, which projects far out over the entrance. In the interior, there are closed seminar rooms as well as open, informal areas for teaching and learning.

Ein weit auskragendes Dach über dem Eingang ist das charakteristische Merkmal des kleinen Hochschulgebäudes. Im Inneren finden sich sowohl geschlossene Seminarräume als auch offene, informelle Bereiche zum Lehren und Lernen.

Le toit en saillie au-dessus de l'entrée est la caractéristique la plus frappante de ce petit bâtiment universitaire. A l'intérieur se trouvent aussi bien des salles de séminaires fermées que des zones informelles ouvertes destinées à l'enseignement et à l'étude.

El tejado de amplio voladizo sobre la entrada es la marca significativa del edificio de esta escuela superior. En el interior se encuentran aulas cerradas y espacios abiertos para estudio y para clases.

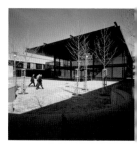

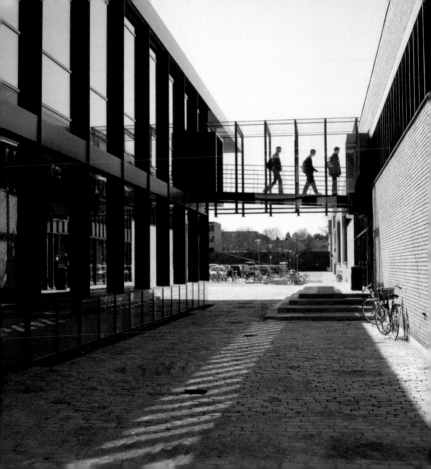

Det Kongelige Bibliotek
The Royal Library

Schmidt, Hammer & Lassen K/S
RAMBØLL Danmark A/S (SE)

1999
Søren Kierkegaards Plads 1
København K

www.kb.dk
www.shl.dk
www.ramboll.dk

The extended wing was placed right in front of the historic library building like a giant monolithic structure. In the interior, the so-called "Black Diamond" includes over seven floors not only library rooms, but also a restaurant, a book store as well as a concert hall for 600 visitors.

Der Erweiterungsbau wurde wie ein riesiger Monolith unmittelbar vor die historischen Bibliotheks-gebäude gesetzt. Im Inneren birgt der so genannte „Schwarze Diamant" auf sieben Geschossen nicht nur Bibliotheksräume, sondern auch ein Restaurant, eine Buchhandlung sowie einen Konzertsaal für 600 Besucher.

L'extension a été placée, telle un énorme monolithe, directement devant le bâtiment historique de la bibliothèque. A l'intérieur, le dénommé « Diamant noir » n'héberge pas seulement des salles de bibliothèque sur sept étages mais aussi un restaurant, une librairie et une salle de concert accueillant 600 visiteurs.

La ampliación de la biblioteca se construyó en una estructura mo-nolítica, justo delante del edificio histórico. El interior del llamado "diamante negro", esconde ade-más de salas de lectura, restau-rante, librería y una sala de con-ciertos para 600 espectadores.

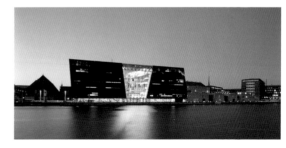

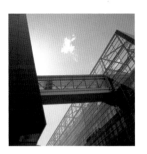

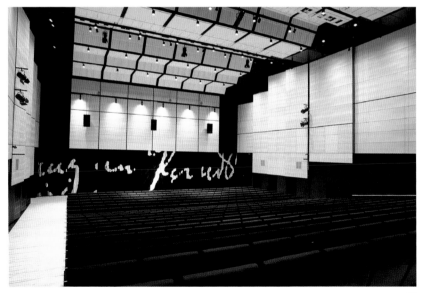

87

Metro

KHR Arkitekter A/S

2002
Kongens Nytorv
København K

www.m.dk
www.khr.dk

The new stop appears spacious and open-plan in contrast to many other subway stations. Instead of elevators, stairs and escalators being fed through narrow pipes, they are channelled into a large, joint shaft that lets daylight flood in right to the platform 22 m below ground.

Im Gegensatz zu vielen anderen Metrostationen wirkt die neue Haltestelle großzügig und übersichtlich. Statt durch enge Röhren, werden Aufzüge, Treppen und Rolltreppen in einem großen, gemeinsamen Schacht geführt, durch den Tageslicht bis auf den Bahnsteig in 22 m Tiefe gelangt.

Contrairement à bien d'autres stations de métro, ce nouvel arrêt paraît spacieux et clairement agencé. Les ascenseurs, escaliers et escalators ne passent pas par d'étroits boyaux mais dans un grand puits commun qui répand la lumière du jour sur les quais à 22 m de profondeur.

Al contrario que muchas estaciones de metro ésta da sensación de amplitud y accesibilidad. En lugar de insertar las escaleras y los ascensores en estrechos canales se han instalado dentro de una enorme caja a través de la cuál la luz solar alcanza los andenes a 22 m de profundidad.

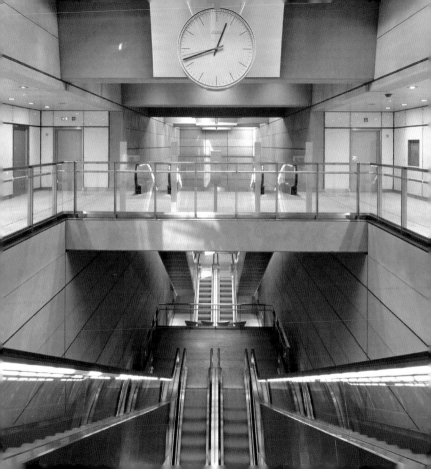

High Square

PLOT

2005
Kgs. Nytorv 13
København K

www.plot.dk

High Square is rightly named so: it is located on the roof of the Magasin du Nord—one of Copenhagen's largest department stores. This astonishing new square is supposed to be used all year round—in winter, a spectacular tobbogan run is created out of the seating steps of the open-air cinema.

Der High Square trägt seinen Namen zu recht: Er liegt auf dem Dach des Magasin du Nord – einem der größten Kaufhäuser Kopenhagens. Dieser erstaunliche neue Platz soll ganzjährig nutzbar sein – im Winter wird aus den Sitzstufen des Freiluftkinos eine spektakuläre Rodelbahn.

Le High Square porte bien son nom : il se trouve sur le toit du Magasin du Nord – l'un des grands magasins les plus importants de Copenhague. Ce nouvel endroit surprenant est utilisable toute l'année – en hiver les gradins du cinéma en plein air se transforment en une formidable piste de luge.

La High Square lleva su nombre con razón ya que está ubicada sobre el tejado del Magasin du Nord, uno de los más importantes grandes almacenes de Copenhague. Esta impresionante plaza nueva está concebida para poder sacar partido de ella todo el año: en invierno los asientos del cine al aire libre se transforman en una espectacular pista de luge.

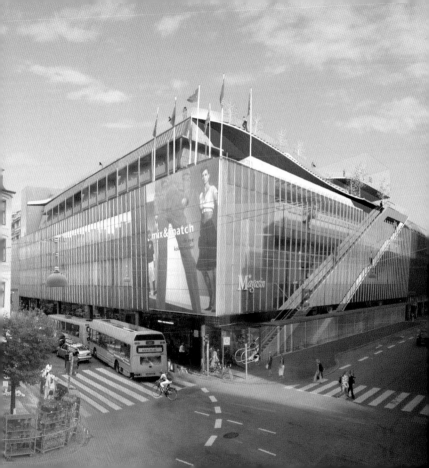

Viktoriagade Kindergarten

Nøhr & Sigsgaard Arkitektfirma A/S

2002
Viktoriagade 26
København V

www.nsark.dk

The four-storey kindergarten integrates into the surrounding block of buildings. A communal zone with access to the garden is located on the ground floor; and group rooms for a total of 48 children are situated above. A large roof terrace serves as an additional play and free area.

Der viergeschossige Kindergarten fügt sich in den umgebenden Gebäudeblock ein. Im Erdgeschoss befindet sich eine Gemeinschaftszone mit Zugang zum Garten; darüber liegen Gruppenräume für insgesamt 48 Kinder. Eine große Dachterrasse dient als zusätzlicher Spiel- und Freibereich.

Ce jardin d'enfants de quatre étages s'intègre dans le bloc de bâtiments attenants. Au rez-de-chaussée se trouvent une zone communautaire donnant accès au jardin et au-dessus les salles de groupe pour 48 enfants maximum. La grande toiture-terrasse est un terrain de jeux et de liberté supplémentaire.

Este jardín de infancia de cuatro plantas está insertado en el entorno de edificios que lo rodea. En la planta baja se encuentra una zona colectiva con acceso al jardín. Por encima de ella están ubicadas las salas para grupos de 48 niños. La amplia terraza del tejado sirve de espacio abierto de juegos.

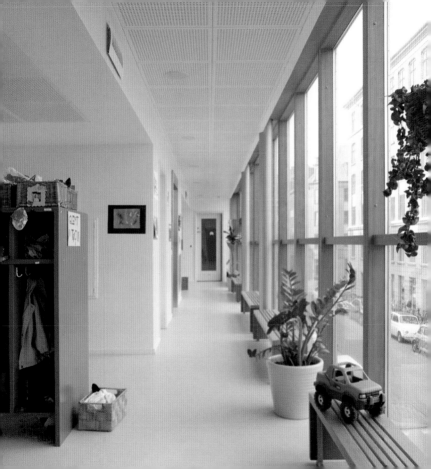

Dannebrogsgade Kindergarten

Entasis A/S – Christian Cold
Wissenberg (SE)

2002
Dannebrogsgade 49
København V

www.entasis.dk
www.wissenberg.com

At first sight, you would not exactly think that this building is a kindergarten. However, behind the strict façades out of black steel panels and the glass elements that extend over an entire floor, there are light, spacious and inviting areas for free playing and learning.

Auf den ersten Blick würde man diesen Bau nicht unbedingt für einen Kindergarten halten. Hinter der strengen Fassade aus schwarzem Stahlblech und den geschosshohen Glaselementen jedoch liegen lichte, großzügige Flächen, die zum freien Spielen und Lernen einladen.

A première vue on n'imaginerait pas que ce bâtiment est un jardin d'enfants. Derrière la façade austère de tôles d'acier noires et de vitrages à hauteur d'étage s'étendent de larges espaces lumineux qui invitent à jouer librement et à apprendre.

A primera vista esta construcción no da la impresión de ser un jardín de infancia. Tras la rígida fachada de chapa de acero y los elementos de vidrio que cubren en altura una planta completa, se muestran espacios abiertos y amplios que incitan al juego y al estudio libre.

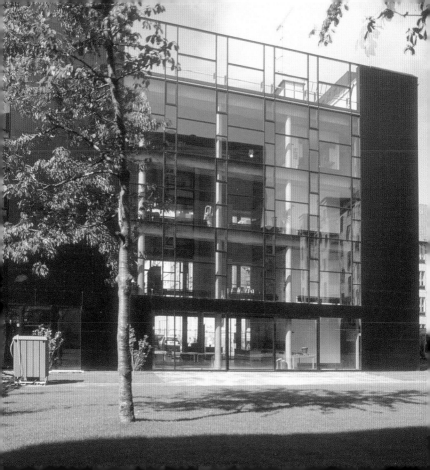

Næstvedgade Kindergarten

Dorte Mandrup Arkitekter ApS
Moe & Brødsgaard (SE)

2004
Næstvedgade 3
København Ø

www.dortemandrup.dk
www.moe.dk

The kindergarten appears anything but playful with its strict geometry and rather cool materials. But the generous rooms for groups provide ideal conditions for children: glass façades towards the garden make it possible for an intensive experience of nature and the changing seasons.

Mit seiner strengen Geometrie und den eher kühlen Materilien wirkt der Kindergarten alles andere als verspielt. Die großzügigen Gruppenräume bieten für Kinder jedoch ideale Bedingungen: Glasfassaden zum Garten ermöglichen das intensive Erleben der Natur und der wechselnden Jahreszeiten.

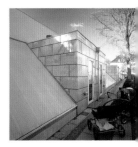

Avec sa géométrie stricte et des matériaux assez froids ce jardin d'enfants est loin d'être gai. Pourtant les salles de groupe spacieuses offrent aux enfants des conditions idéales : les façades de verre donnant sur le jardin permettent de se sentir très proche de la nature et de l'alternance des saisons.

Vista su rígida geometría y los materiales más bien fríos utilizados para la construcción, este jardín de infancia no tiene un aire muy infantil. Sin embargo, las amplias salas colectivas ofrecen las condiciones ideales para niños. Las fachadas de vidrio que dan al jardín proporcionan la posibilidad de vivir la naturaleza y el cambio de las estaciones de forma intensiva.

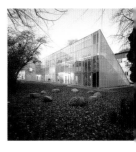

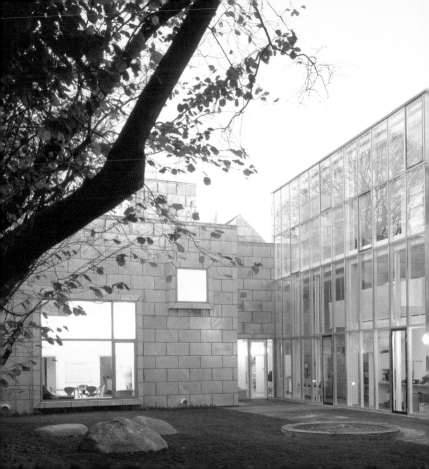

DFDS Seaways Terminal

3XNielsen A/S
COWI A/S (SE)

2004
Dampfærgevej 30
Søndre Frihavn
København Ø

www.dfdsseaways.dk
www.3xnielsen.dk
www.cowi.dk

The long expanse of the ferry terminal includes passport and customs controls, ticket desks, waiting zones and a shopping area. Three ferries carrying a total of 2.000 passengers can be checked in without any problem. Four different types of glass in the façade ensure a fascinating and diverse overall look by night.

Der lang gestreckte Bau des Fährterminals enthält Pass- und Zollkontrollen, Ticket-Schalter, Wartezonen und einen Shopping-Bereich. Drei Fähren mit insgesamt 2.000 Passagieren können problemlos abgefertigt werden. Vier verschiedene Glasarten in der Fassade sorgen besonders bei Nacht für einen faszinierenden und vielschichtigen Gesamteindruck.

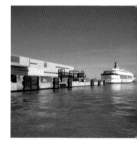

Le bâtiment tout en longueur du terminal des ferries abrite le contrôle des passeports et des douanes, la billetterie, les zones d'attente et un espace commercial. On procède sans problème à l'enregistrement des 2.000 passagers de trois ferries. La façade émerveille avec ses quatre types de verre différents et, la nuit surtout, brille de mille feux.

La construcción alargada de la terminal del ferry cuenta con control de pasaportes y aduana, ventanillas para billetes, salas de espera y un espacio comercial. La envergadura permite estacionar sin problemas tres ferry con una capacidad total de 2.000 pasajeros. Los cuatro tipos diferentes de vidrio que cubren la fachada proporcionan un espectáculo nocturno cambiante y fascinante.

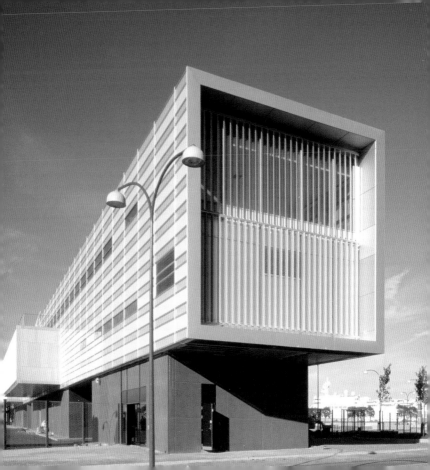

Flintholm Station

KHR Arkitekter A/S
COWI A/S (SE)
Arup (SE)

2003
Grøndalsparken
Frederiksberg

www.khr.dk
www.cowi.dk
www.arup.com

An enormous glass roof joins three different stations—subway, train and city transit—to a single, continuous station building. The primary aims of the planners were security, easy surveillance and short routes for passengers.

Ein riesiges Glasdach fasst drei verschiedene Stationen – Metro, Fernbahn und S-Bahn – zu einem zusammenhängenden Bahnhofsgebäude zusammen. Oberste Ziele der Planer waren Sicherheit, Übersichtlichkeit und kurze Wege für die Passagiere.

Une immense toiture de verre centralise trois stations différentes – métro, trains grandes lignes et réseau express – dans une gare d'un seul tenant. La priorité absolue des concepteurs était la sécurité, la clarté de l'agencement et de courtes distances pour les voyageurs.

Un enorme tejado de vidrio engloba tres estaciones diferentes, metro, tren de largo recorrido y tranvía, en un edificio común. Los objetivos primordiales de este proyecto eran la seguridad, la facilidad de orientación y crear los recorridos más cortos posibles para los pasajeros.

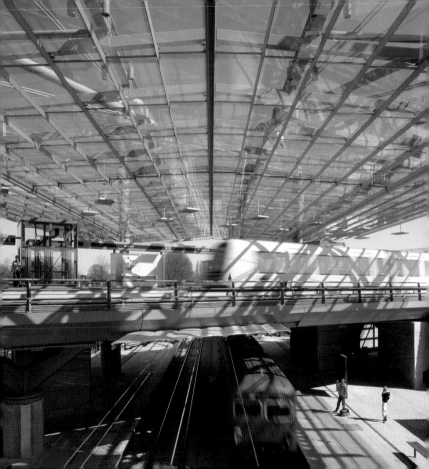

Zoo - Main Entrance

Entasis A/S – Christian Cold
RAMBØLL Danmark A/S (SE)

1998
Roskildevej 30
Frederiksberg

www.zoo.dk
www.entasis.dk
www.ramboll.dk

In the angular scheme of the buildings, there are not only classical entrance facilities, such as a ticket and information desk, but also shops, a lecture theater and rooms for personnel. A sophisticated design of the external areas joins the new entrance into the zoo's overall facility.

In den winkelförmig angeordneten Bauten finden sich nicht nur klassische Eingangsfunktionen wie Ticket- und Infoschalter, sondern auch Shops, ein Vortragsraum sowie Räume für die Mitarbeiter. Eine aufwändige Gestaltung der Außenbereiche bindet den neuen Eingang in die Gesamtanlage des Zoos ein.

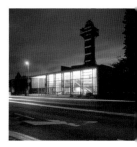

Dans les bâtiments disposés à angle droit il n'y a pas seulement les fonctionnalités classiques d'une entrée telles que les guichets tickets et informations mais aussi des boutiques, une salle de conférences et des locaux pour les employés. Un agencement étudié des extérieurs intègre la nouvelle entrée aux installations du zoo.

Los edificios tienen una disposición angular y cuentan, no sólo con los servicios habituales de la entrada, ventanillas de información y venta de entradas, sino también con comercios, salas de conferencias y salas para los empleados. La aparatosa concepción de los espacios exteriores inserta la nueva entrada en las instalaciones del zoo.

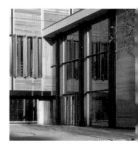

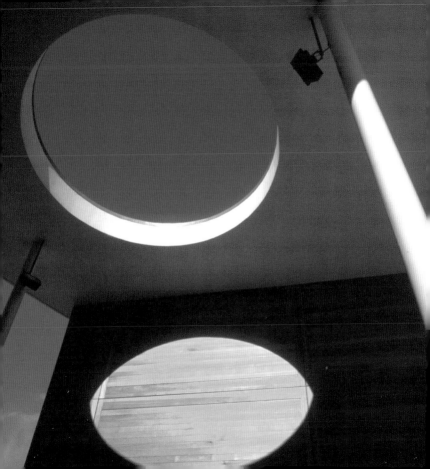

Elephant House

Foster and Partners

2002
Roskildevej 32
Frederiksberg

www.zoo.dk
www.fosterandpartners.com

The new elephant house accommodates the animals' needs in a special way: as in nature, male and female animals live separately. Two glass dome roofs cover both of the enclosures; a surrounding visitor deck combines both parts to a single building.

Das neue Elefantenhaus geht in besonderer Weise auf die Bedürfnisse der Tiere ein: Wie in der Natur, leben männliche und weibliche Tiere getrennt. Zwei gläserne Kuppeln überdecken die beiden Gehege; eine umlaufende Besucherterrasse verbindet beide Teile zu einem Gebäude.

La nouvelle maison des éléphants tient compte des besoins des animaux de manière particulière : comme dans la nature, mâles et femelles vivent séparément. Deux coupoles en verre couvrent les deux enclos ; raccordés par une terrasse circulaire pour les visiteurs, ils forment un seul bâtiment.

La nueva casa de los elefantes se centra de forma especial en las necesidades de los animales. Al igual que en la naturaleza, aquí habitan los elefantes hembra y macho por separado. Dos cúpulas de vidrio cubren ambos recintos y una terraza para los visitantes recorre y unifica ambas partes en un sólo edificio.

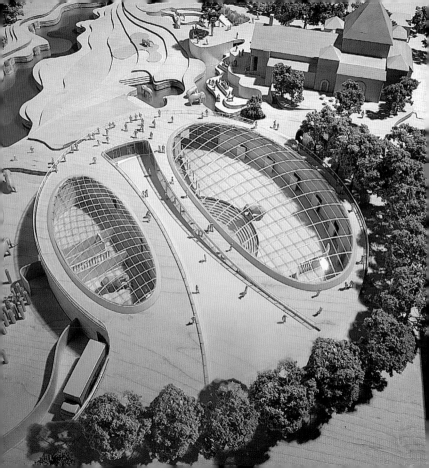

Kvarterhus Jemtelandsgade

Dorte Mandrup Arkitekter ApS
Dominia A/S (SE)

2001
Jemtelandsgade 3
København S

www.kvarterhuset.dk
www.dortemandrup.dk
www.dominia.dk

A building dating from 1880 was transformed into a citizens' center with library, café and offices. Parts of the ceilings were removed, in order to create a generous foyer that extends over three floors. A glass extension rests like a tree house on concrete stilts, which are arranged in an irregular pattern.

Ein Gebäude aus dem Jahr 1880 wurde zu einem Bürgerhaus mit Bibliothek, Café und Büros umgewandelt. Teile der Decken wurden entfernt, um ein großzügiges, drei Geschosse umfassendes Foyer zu schaffen. Ein gläserner Anbau ruht wie ein Baumhaus auf Betonstützen, die in einem unregelmäßigen Raster angeordnet sind.

Un bâtiment datant de 1880 s'est transformé en une « maison de quartier » avec une bibliothèque, un café et des bureaux. Une partie des plafonds a été supprimée pour créer un hall englobant trois étages. Une annexe de verre repose comme un arbre maison sur des piliers de béton disposés selon une trame irrégulière.

Un edificio del año 1880 se ha convertido en un centro cívico con biblioteca, cafetería y oficinas. Se han eliminado algunas partes del techo para construir un amplio vestíbulo que abarca tres plantas. Al lado, un anexo de vidrio se levanta como una casa en un árbol, apoyada en soportes de hormigón alineados de forma irregular.

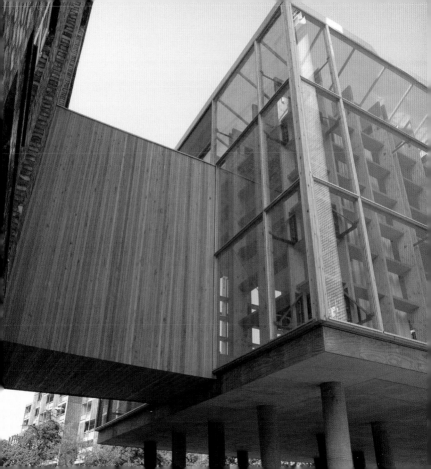

Bella Center Auditorium

DISSING+WEITLING arkitektfirma a/s
NIRAS A/S (SE)

2000
Center Boulevard 5
København S

www.bellacenter.dk
www.niras.dk
www.dw.dk

A large auditorium was added to the congress center in the south of Copenhagen. Its striking form is an eye-catching feature that nevertheless integrates harmoniously into the existing site. The large hall for an audience of over 900 can be divided into three smaller units, each accommodating 300 people.

Das Kongresszentrum im Süden Kopenhagens wurde um ein großes Auditorium ergänzt. Mit seiner markanten Form setzt es ein auffallendes, neues Zeichen, fügt sich aber dennoch harmonisch in die vorhandene Anlage ein. Der große Saal für über 900 Zuhörer kann in drei kleinere Einheiten für jeweils 300 Personen unterteilt werden.

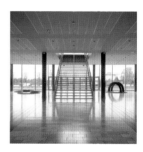

Le palais des congrès au sud de Copenhague a été complété par un grand auditorium. Sa forme remarquable est très frappante mais elle s'intègre cependant harmonieusement dans l'installation existante. La grande salle accueillant plus de 900 auditeurs peut se diviser en trois petites unités de 300 personnes chacune.

El centro de congresos situado al sur de Copenhague ha sido ampliado con un gran auditorio. Su personal forma resalta de forma significativa, sin embargo se integra armónicamente en la estructura ya existente. La vasta sala alberga a 900 espectadores y se puede reducir a tres espacios menores con capacidad para 300 personas.

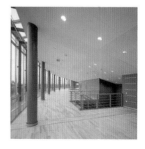

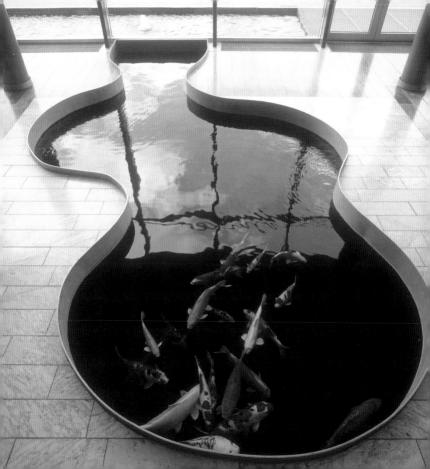

Maritime Youth House

PLOT
Jesper Gudman (SE)
Birch & Krogboe A/S (SE)

2004
Amager Strandvej 13
København S

www.plot.dk
www.birch-krogboe.dk

A quarter of the entire budget for the youth center was originally meant to be used for a clean-up operation to remove various contaminated materials from the site. But the architects had a better idea: the building itself functions as a large, wooden sight-screen where youngsters can now play without any danger.

Ein Viertel des Gesamtbudgets für das Jugendzentrum sollte ursprünglich für die Reinigung des Grundstücks von verschiedenen Altlasten aufgewendet werden. Die Architekten hatten jedoch eine bessere Idee: Das Gebäude selbst wirkt als große, hölzerne Schutzschicht, auf der die Jugendlichen nun gefahrlos spielen können.

Un quart du budget total destiné à la maison des jeunes devait à l'origine être consacré à la dépollution du terrain de divers résidus toxiques. Mais les architectes ont eu une meilleure idée : le bâtiment même fait l'effet d'une grande couche protectrice de bois sur laquelle les jeunes peuvent désormais jouer sans danger.

Un cuarto del presupuesto total previsto para el centro de jóvenes estaba destinado en un principio a la limpieza de varias basureras que había en el terreno. Sin embargo, los arquitectos tuvieron una idea mejor: construir el edificio como una gran plancha protectora en madera sobre la que los jóvenes pueden jugar sin peligro.

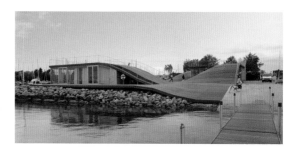

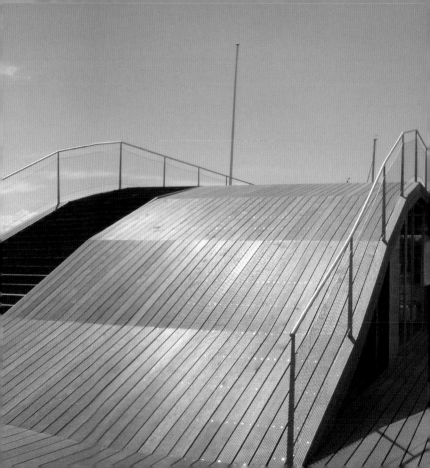

Sundpark Kindergarten

Nøhr & Sigsgaard Arkitektfirma A/S

2002
Strandlodsvej 73 / Øresundsvej 131
København S

www.nsark.dk

The kindergarten and day nursery have sloping façades and roofs—it almost seems as if they might sink into the floor. A long corridor running along the entrance façade serves as a communal area with zones accommodating adults and children.

Kindergarten und Tagesstätte haben geneigte Fassaden und Dächer – fast scheint es, als würden sie im Erboden versinken. Ein langer Korridor entlang der Eingangsfassade dient als Gemeinschaftszone mit Aufenthaltsbereichen für Erwachsene und Kinder.

Les façades et les toits du jardin d'enfants et de la garderie sont inclinés – comme s'ils allaient s'enfoncer dans le sol. Un long corridor le long de la façade d'entrée sert de zone communautaire avec des espaces libres pour les adultes et les enfants.

El jardín de infancia y el centro de día tienen una fachada y tejado inclinados que parecen hundirse en el suelo. Un extenso pasillo a lo largo de la fachada de entrada sirve de espacio común con salas de estar para niños y adultos.

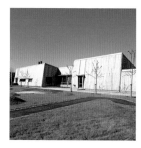

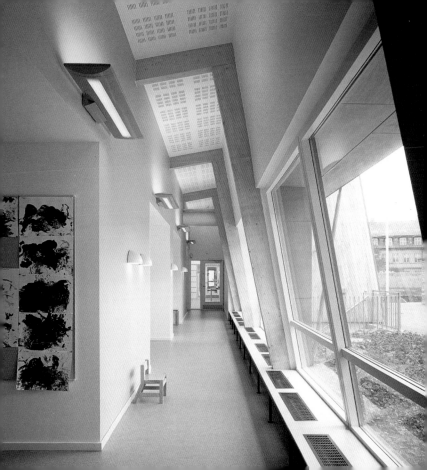

to stay . hotels

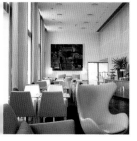
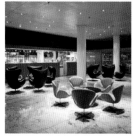

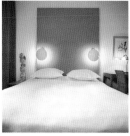
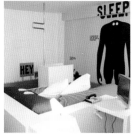

115

Imperial

AK83 Arkitektkontoret
Interiør-Gruppen ApS
Arpe & Kjeldsholm A/S (SE)

2005
Vester Farimagsgade 9
København V

www.imperialhotel.dk
www.ak83.dk
www.interior-gruppen.com

The Imperial is distinguished not only by its magnificent location, but also by its sophisticated interior furnishing. The rooms were designed by different Danish designers, which gives the entire building a special, individual touch.

Das Imperial zeichnet sich nicht nur durch seine hervorragende Lage, sondern auch durch eine anspruchsvolle Inneneinrichtung aus. Die Zimmer wurden von verschiedenen dänischen Designern gestaltet, was dem ganzen Haus eine besondere, individuelle Note verleiht.

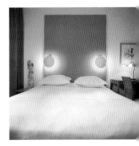

L'Imperial ne se distingue pas seulement par son emplacement exceptionnel mais surtout par la classe de sa décoration intérieure. Les chambres ont été dessinées par différents designers danois, ce qui donne à tout l'établissement un cachet individuel particulier.

El Imperial no sólo se caracteriza por su fenomenal ubicación sino también por un diseño interior exigente. Las habitaciones han sido concebidas por diferentes diseñadores daneses, lo que dota a todo el lugar de un carácter individual.

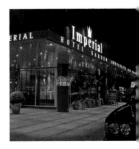

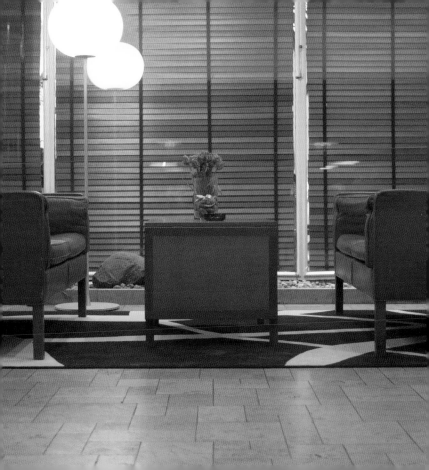

Radisson SAS Royal Hotel

mahmoudieh design

2001
Hammerichsgade 1
København V

www.radissonsas.com
www.mahmoudieh.de

The SAS Radisson in Copenhagen is regarded as one of the most important works by Arne Jacobsen. Nevertheless, with the exception of one suite, all the hotel rooms as well as the lobby and conference areas were newly designed and furnished. The attempt was also to take into account 1950's style in the new interiors.

Das Radisson SAS in Kopenhagen gilt als eines der wichtigsten Werke von Arne Jacobsen. Dennoch wurden – mit Ausnahme einer Suite – sämtliche Hotelzimmer sowie die Lobby und die Konferenzbereiche neu gestaltet und eingerichtet. Dabei wurde versucht, dem Geist der fünfziger Jahre auch in den neuen Interieurs Rechnung zu tragen.

Le Radisson SAS de Copenhague est réputé pour être l'une des œuvres les plus importantes d'Arne Jacobsen. Pourtant, toutes les chambres – à l'exception d'une suite –, le hall d'entrée et les salles de conférences ont été redessinés et réaménagés. On s'est alors attaché à prendre en compte l'esprit des années cinquante y compris dans les nouveaux intérieurs.

El Radisson SAS de Copenhague se considera una de las obras más importantes de Arne Jacobsen. Ahora bien, exceptuando una suite, todas las habitaciones del hotel, además del lobby y los espacios para conferencias han sido diseñados y decorados de nuevo. En los nuevos interiores se ha querido tener en cuenta el espíritu de los años cincuenta.

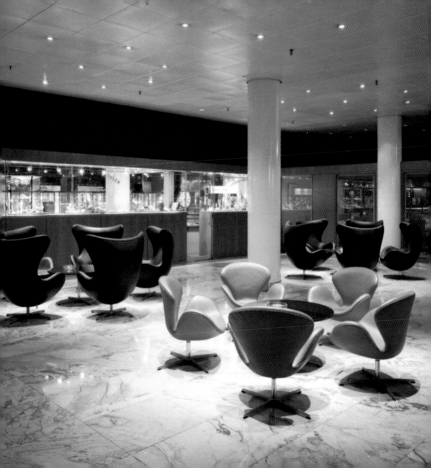

The Square

AK83 Arkitektkontoret
Interiør-Gruppen ApS
KPC Byg A/S (SE)

2003
Raadhuspladsen 14
København V

www.thesquare.dk
www.ak83.dk
www.interior-gruppen.com
www.kpc-byg.dk

The square not only gives the hotel its name, but it also emerges as a repeated motif in many details of the interior furnishing. A large number of the rooms and the breakfast restaurant on the sixth floor offer guests an excellent view of the town hall square and of the city.

Das Quadrat ist nicht nur Namensgeber des Hotels, sondern taucht als wiederkehrendes Motiv auch in vielen Details der Innenausstattung auf. Eine Großteil der Zimmer und das Frühstücksrestaurant im sechsten Stock bieten den Gästen einen exzellenten Blick auf den Rathausplatz und über die Stadt.

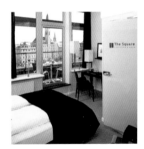

Le carré donne son nom à l'hôtel mais c'est aussi le motif qui se répète dans de nombreux détails de l'aménagement intérieur. Une grande partie des chambres et la salle du petit déjeuner au sixième étage offrent aux hôtes une magnifique vue sur la place de l'hôtel de ville et la ville.

El cuadrado es ahora no sólo el nombre del hotel sino que reaparece como motivo en muchos de los detalles de la decoración interior. La mayor parte de las habitaciones y el restaurante para desayunos del sexto piso ofrecen a los huéspedes unas vistas excelentes a la plaza del ayuntamiento y a toda la ciudad.

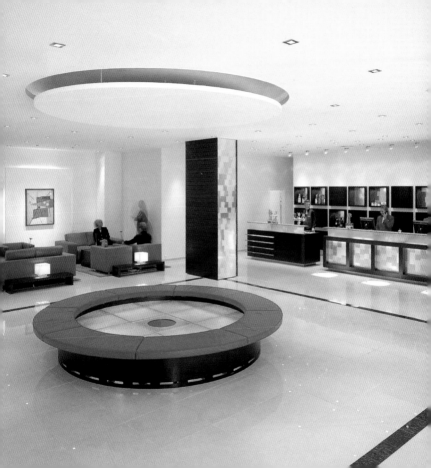

Fox

International Artists

2004
Jarmers Plads 3
København V

www.hotelfox.dk

The hotel Fox was redesigned by a whole series of different artists and designers as part of an advertizing campaign by a car manufacturer. In the process, every hotel room was given individual artistic furnishing. This partly became so extravagant that it might be difficult to get some sleep.

Das Fox-Hotel wurde als Teil der Werbekampagne eines Autoherstellers von einer ganzen Reihe unterschiedlicher Künstler und Designer neu gestaltet. Jedes Hotelzimmer erhielt dabei eine individuelle künstlerische Ausstattung. Diese ist zum Teil so extravagant geraten, dass es schwer sein dürfte, ein Auge zuzumachen.

L'hôtel Fox a été redessiné par une série d'artistes et de designers dans le cadre de la campagne publicitaire d'un constructeur automobile. Ainsi chaque chambre a-t-elle reçu un aménagement artistique individuel. Le résultat de cette décoration est quelquefois si extravagant qu'on a peine à fermer l'œil.

El hotel Fox ha sido renovado por completo por diversos artistas y diseñadores en el marco de una campaña publicitaria. Cada una de las habitaciones cuenta con una decoración artística individualizada y, en parte tan extravagante, que en realidad debería resultar imposible pegar ojo en ella.

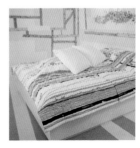

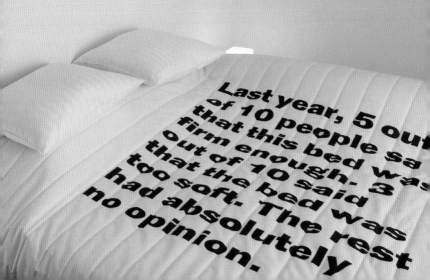

82% of all
European hotel
rooms feature
a romantic
landscape
painting

77% of all
rooms in D
have white

Last year, 5 out
of 10 people sa
that this bed wa
firm enough. 3
out of 10 said
that the bed was
too soft. The rest
had absolutely
no opinion.

Skt. Petri

Erik Møllers Tegnestue A/S
Birch & Krogboe A/S (SE)

2003
Krystalgade 22
København K

www.hotelsktpetri.com
www.emt.dk
www.birch-krogboe.dk

The building was designed between 1933 and 1935 by Vilhelm Lauritzen. In the meantime, it was rebuilt as an elegant design hotel. The former inner courtyard is under roof cover—the lobby, restaurant, reception as well as the hotel's function room are now all located here.

Das Gebäude wurde 1933 bis 1935 von Vilhelm Lauritzen als Kaufhaus entworfen. Inzwischen wurde es zu einem eleganten Design-Hotel umgebaut. Der ehemalige Innenhof ist überdacht – hier befinden sich nun Lobby, Restaurant, Rezeption sowie der Veranstaltungssaal des Hotels.

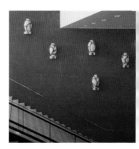

Le bâtiment a été conçu de 1933 à 1935 par Vilhelm Lauritzen comme grand magasin. Entre temps il a été transformé en hôtel design élégant. L'ancienne cour intérieure est couverte – c'est là que se trouvent désormais le hall d'entrée, le restaurant, la réception et la salle de manifestations de l'hôtel.

El edificio fue proyectado por Vilhelm Lauritzen de 1933 a 1935 como un gran almacén. Posteriormente pasó a transformarse en un elegante hotel de diseño. Se ha cubierto el antiguo patio interior para albergar en él lobby, restaurante, recepción y sala de convenciones.

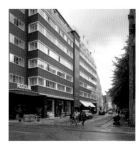

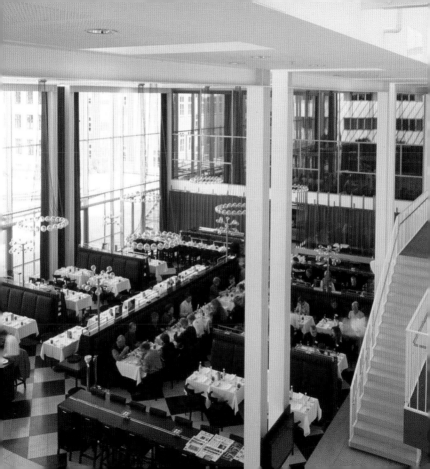

Admiral Hotel

Conran & Partners

2003
Toldbodgade 24-28
København K

www.admiralhotel.dk
www.conranandpartners.com

The old warehouse that is over 200 years old has already been used as a hotel since 1978. In the meantime, the building was painstakingly renovated—also in respect of the neighborhood around the new opera house and what will in future also be the theater. The entire interior was specially designed and made for this hotel.

Das über 200 Jahre alte Lagerhaus wird bereits seit 1978 als Hotel genutzt. Inzwischen wurde das Haus – auch im Hinblick auf die Nachbarschaft zur neuen Oper und künftig auch zum Schauspielhaus – aufwändig saniert. Dabei wurde das gesamte Interieur eigens für dieses Hotel entworfen und angefertigt.

Cet ancien entrepôt de plus de 200 ans a été transformé en hôtel dès 1978. Etant donné qu'il est proche du nouvel opéra mais aussi du futur théâtre, l'édifice a été entre temps entièrement rénové. A cette occasion, tous les intérieurs ont été spécialement conçus et fabriqués pour cet hôtel.

Este almacén de más de 200 años hace la función de hotel desde 1978. Entre tanto el edificio ha sido saneado completamente, con vistas a la cercanía de la nueva ópera y al futuro teatro. El interior del hotel ha sido esbozado y confeccionado especialmente para esta casa.

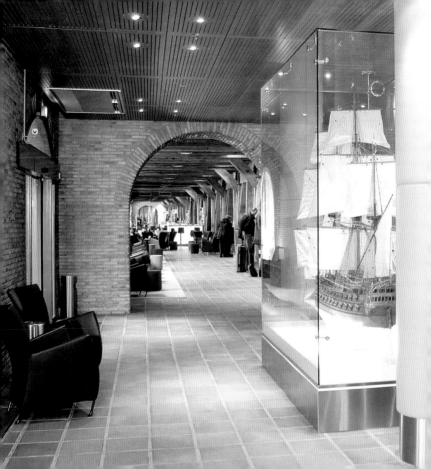

Hilton Copenhagen Airport

Vilhelm Lauritzen A/S
NIRAS A/S (SE)

2000
Ellehammersvej 20
Kastrup

www.hilton.com
www.vla.dk
www.niras.dk

The Hilton Copenhagen Airport is convincing because of its elegant, typically Scandinavian interior furnishing. The windows of the hotel rooms are as high as the separate floors and offer fabuluous views over the city and airport.

Das Hilton Copenhagen Airport überzeugt durch seine elegante, typisch skandinavische Innenausstattung. Die geschosshohen Fenster der Hotelzimmer bieten großartige Ausblicke über die Stadt und auf den Flughafen.

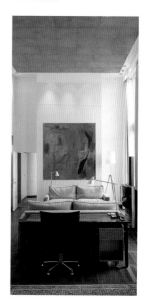

Le Hilton Copenhagen Airport affiche une élégance très convaincante dans son aménagement intérieur typiquement scandinave. Les fenêtres des chambres à hauteur d'étage offrent une vue splendide sur la ville et l'aéroport.

El Hilton Copenhagen Airport convence por sus interiores elegantes y típicos escandinavos. Las ventanas, cuya altura es de toda una planta ofrecen vistas magnificas a la ciudad y al aeropuerto.

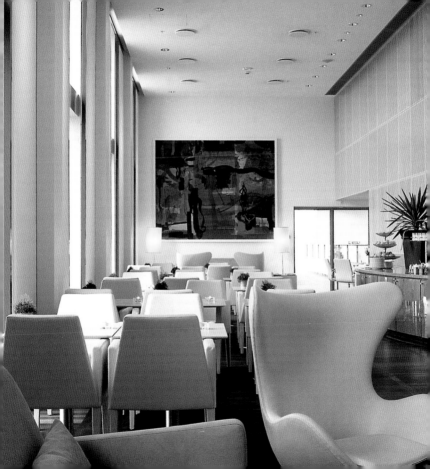

to go . eating
drinking
clubbing
wellness, beauty & sport

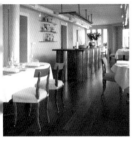
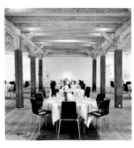
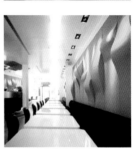
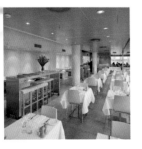
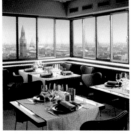
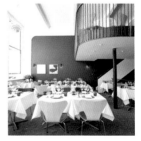

Søren K

Schmidt, Hammer & Lassen K/S

1999
Søren Kierkegaards Plads 1
København K

www.soerenk.dk
www.shl.dk

The restaurant on the ground floor of the royal library is noteworthy for its minimalist elegance, which perfectly integrates into the building's architectural concept. In addition, floor-to-ceiling glass windows offer guests impressive views across the Inderhavnen to the Christianshavn.

Das Restaurant im Sockelgeschoss der königlichen Bibliothek besticht durch eine minimalistische Eleganz, die sich perfekt in das architektonische Konzept des Gebäudes integriert. Geschosshohe Glasscheiben bieten den Gästen zudem beeindruckende Blicke über den Inderhavnen auf Christianshavn.

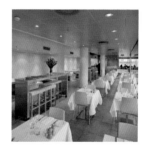

Le restaurant à l'étage du soubassement de la Bibliothéque royale séduit par son élégance minimaliste qui s'intègre à la perfection dans le concept architectural du bâtiment. Les baies vitrées, qui s'étendent du sol au plafond, offrent au public un point de vue exceptionnel sur le Inderhavnen du Christianhavn.

El restaurante de la biblioteca real situado en el zócalo está dotado de una elegancia minimalista que se ensambla a la perfección en el concepto arquitectónico del edificio. Las grandes cristaleras que cubren toda la planta permiten a los visitantes admirar las magníficas vistas sobre Inderhavnen y Christianshavn.

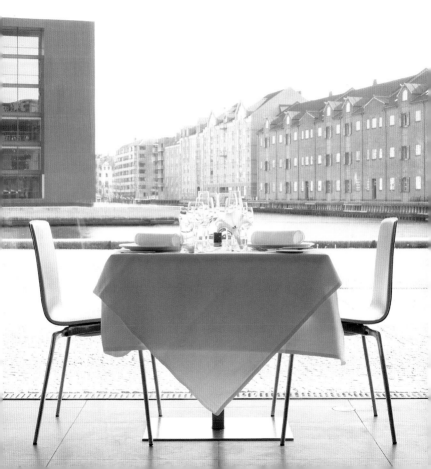

Alberto K

Radisson

2001
Hammerichsgade 1
København V

www.radisson.com

The restaurant is located on the 20th floor of the SAS Radisson Royal Hotel. The kitchen and adjoining rooms are in a central core. This means that all tables have an impressive view over the city. The furnishing is, naturally, remiscent of Arne Jacobsen and the cutlery, which was originally especially designed for this hotel, also continues to be used here.

Le restaurant est au 20ème étage du Radisson SAS Royal Hotel. Le noyau central comprend la cuisine et les pièces attenantes. C'est pourquoi toutes les tables offrent une vue impressionnante sur la ville. Le mobilier est évidemment une réminiscence d'Arne Jacobsen et les couverts créés à l'origine spécialement pour la maison continuent d'être utilisés.

Das Restaurant liegt im 20. Stock des Radisson SAS Royal Hotel. Ein zentraler Kern beinhaltet die Küche und Nebenräume. Dadurch bieten alle Tische beeindruckende Blicke über die Stadt. Das Mobiliar ist – selbstverständlich – eine Reminiszenz an Arne Jacobsen, und auch das ursprünglich speziell für das Haus entworfene Besteck findet hier weiterhin Verwendung.

El restaurante está ubicado en el piso 20 del hotel Radisson SAS Royal Hotel. El núcleo central incluye la cocina y las salas adjuntas. Con ello, desde todas las mesas del local se pueden presenciar las magníficas vistas a la ciudad. El mobiliario tiene por supuesto reminiscencias de Arne Jacobsen, e incluso los cubiertos que en origen fueron diseñados para esta casa aún siguen en uso.

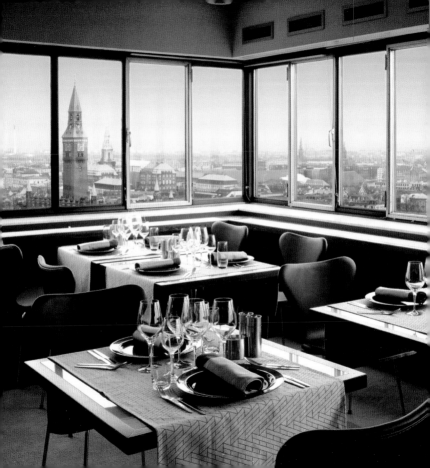

NASA nightclub

Johannes Torpe Studios ApS

2005
Gothersgade 8D - Boltens Gaard
København K

www.nasa.dk
www.johannestorpe.com

You could easily go snow-blind in this club—the entire furnishing is kept in brilliant white. The soft, flowing forms of the bar and the couchs still ensure a relaxed and light-hearted mood.

In diesem Club könnte man leicht schneeblind werden – die gesamte Einrichtung ist in reinem Weiß gehalten. Die weichen, fließenden Formen der Bar und der Couches sorgen dennoch für eine entspannte und legere Stimmung.

Dans ce club on pourrait être atteint de l'ophtalmie des neiges tant la décoration est éclatante blanche. Les formes fluides et moelleuses du bar et des canapés créent pourtant une ambiance légère et détendue.

Este local ciega la vista. Absolutamente todo es de un blanco reluciente. Las suaves y fluidas formas del bar y los sillones se encargan de crear un ambiente de relax y ligereza.

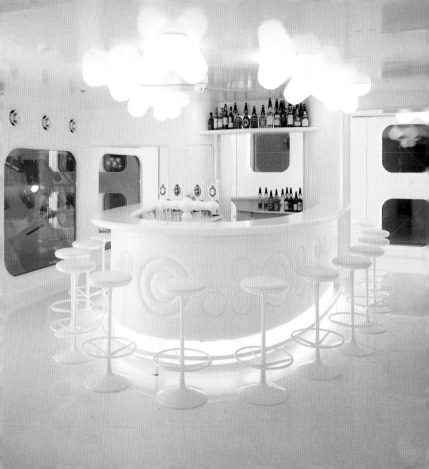

SALT

Conran & Partners

2003
Toldbodgade 24-28
København K

www.saltrestaurant.dk
www.conranandpartners.com

The restaurant's interior is defined by massive columns, supports and beams. The designers contrast this rather rustic style with a modern interior with clear forms and refined colors and give the historic room quite simple and timeless elegance.

Gewaltige Stützen, Streben und Balken bestimmen den Innenraum des Restaurants. Dieser eher rustikalen Ästhetik setzen die Designer ein modernes Interieur mit klaren Formen und noblen Farben entgegen und verleihen dem historischen Raum so schlichte und zeitlose Eleganz.

Poutres, étais et puissants piliers sont les éléments dominants à l'intérieur de ce restaurant. A cette esthétique plutôt rustique les designers opposent un intérieur moderne avec des formes droites et des couleurs nobles, conférant ainsi à ce local historique une élégance simple et intemporelle.

El interior del restaurante está definido por enormes apoyos, travesaños y vigas. Como oposición a esta estética de carácter más bien rústico, los diseñadores han integrado un moderno interior de formas claras y colores nobles dando al edificio histórico una elegancia austera e intemporal.

138

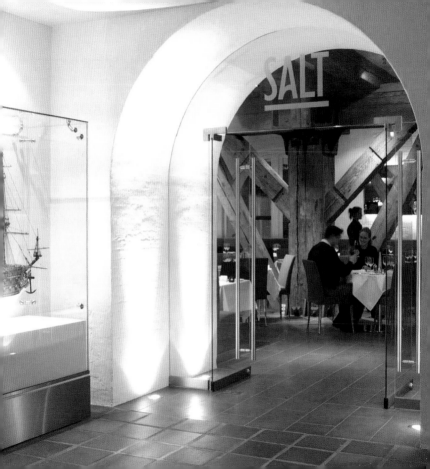

noma

Signe Bindslev Henriksen

2004
Strandgade 93
København K

www.noma.dk

The open wood constructions, whitewashed walls and deep-set window openings create the rough charm of this listed warehouse building. A restrained interior design and elegant furniture underline this fact in a discreet way.

Die offene Holzkonstruktion, weiß gestrichene Wände und die tief eingeschnittenen Fensteröffnungen machen den rauen Charme des denkmalgeschützten Lagergebäudes aus. Eine zurückhaltende Innenausstattung und die elegante Möblierung unterstreichen dies auf unaufdringliche Weise.

La salle aux poutres de bois apparentes, les murs peints en blanc et les fenêtres profondément découpées déterminent le charme rugueux de cet ancien entrepôt classé monument historique. La discrétion de la décoration et l'élégance des meubles le mettent opportunément en valeur.

La construcción abierta de madera, las paredes blancas y los pronunciados vanos de las ventanas dan un encanto tosco a este edificio almacén, declarado patrimonio nacional. Los escuetos interiores y el mobiliario elegante resaltan aún más el encanto de forma discreta.

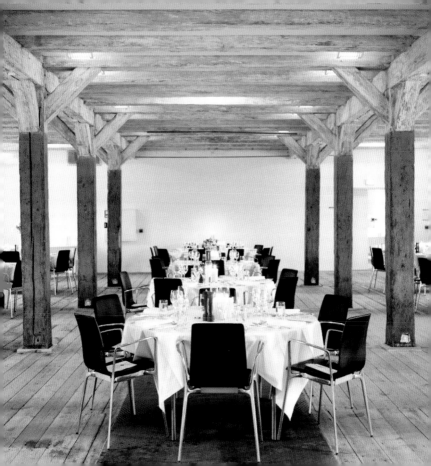

Kokkeriet

Sammy Shafi

2004
Kronprinsessegade 64
København K

www.kokkeriet.dk

In the Kokkeriet, simple materials produce a pleasant, harmonious atmosphere. Cream-colored walls and the dark wooden floor are in contrast to the white, fully laid tables and the bar, which is clad in polished steel panels.

Einfache Mittel erzeugen im Kokkeriet eine angenehme, harmonische Atmosphäre. Cremefarbene Wände und der dunkle Holzfußboden stehen im Kontrast zu den weiß eingedeckten Tischen und der mit blankem Stahlblech verkleideten Theke.

Des moyens simples suffisent à créer une atmosphère agréable et harmonieuse. Les murs couleur crème et le plancher en bois sombre contrastent avec les tables aux nappes blanches et le bar revêtu de tôle d'acier poli.

La atmósfera armónica de Kokkeriet se ha conseguido con medios sencillos. Las paredes en color crema y los suelos oscuros de madera contrastan con el blanco de los manteles de las mesas y la reluciente barra revestida de chapa de acero.

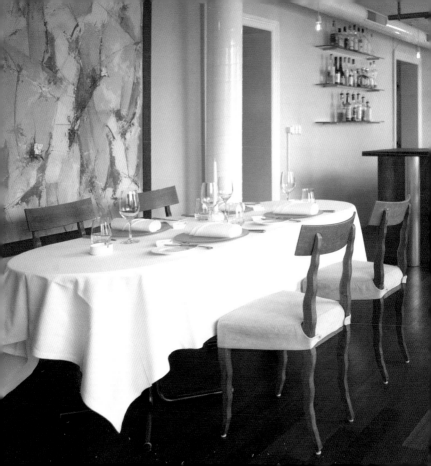

Nørrebro

C. F. Møller Architects
punktum I design

2003
Ryesgade 3
København N

www.norrebrobryghus.dk
www.cfmoller.com
www.punktum-design.dk

The traditional workers' quarter of Nørrebro has transformed itself in recent years into a popular district for going out. It has classy restaurants, bars and designer shops. The brewery regards itself as a sophisticated "gastronomic adventure" with a carefully devised corporate design.

Das traditionelle Arbeiterquartier Nørrebro hat sich in den letzten Jahren in ein beliebtes Szene-Viertel mit schicken Restaurants, Bars und Designer-Shops verwandelt. Das Brauhaus versteht sich als anspruchsvolle „Erlebnisgastronomie" mit einem sorgfältig gestalteten Corporate Design.

Le traditionnel quartier ouvrier de Nørrebro s'est transformé ces dernières années en un quartier tendance populaire avec ses restaurants, bars et boutiques design chic. La brasserie incarne une « gastronomie événement » haut de gamme avec un Corporate Design soigneusement étudié.

El tradicional barrio de trabajadores Nørrebro se ha transformado en los últimos años en uno de los lugares de moda, con restaurantes elegantes, pubs y comercios de diseño. Esta cervecería está concebida como un lugar de alta gastronomía con un cuidado Corporate Design.

144

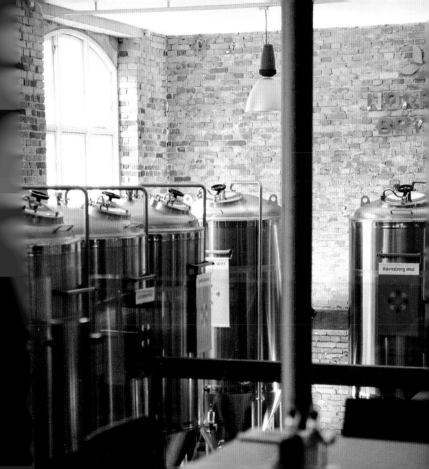

SuperGeil

Johannes Torpe Studios ApS

2001
Nørrebrogade 184
København N

www.johannestorpe.com

Supercool would probably have been an even more suitable name for this bar. The furnishing is kept totally in black and white and silver, only the orange wall elements introduce a colorful note and their form language is reminiscent of Verner Panton.

Supercool wäre als Name für diese Bar womöglich noch passender gewesen. Die Einrichtung ist komplett in Schwarz-Weiß und Silber gehalten, lediglich orange Wandelemente, die in ihrer Formensprache an Verner Panton erinnern, setzen einen farbigen Akzent.

Supercool est un nom qui conviendrait mieux à ce bar. La décoration est entièrement en noir-blanc et argent ; seuls des éléments muraux orange qui rappellent Verner Panton dans leur expression formelle, mettent une touche de couleur.

Para este pub hubiera sido aún más acertado el nombre de "Supercool". La decoración se ha creado completamente en blanco, negro y plateado. Lo único que marca un acento de color son los elementos naranjas de las paredes, cuyo lenguaje de formas recuerda a Verner Panton.

146

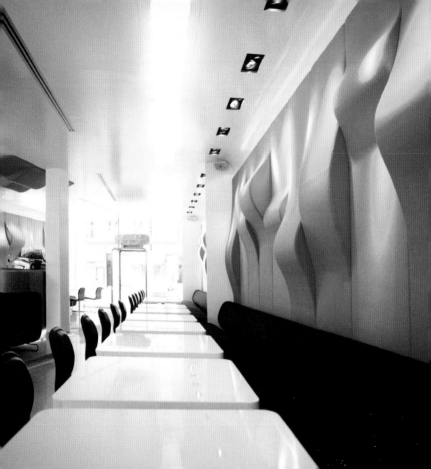

Formel B

Signe Bindslev Henriksen

1997
Vesterbrogade 182
Frederiksberg C

www.formel-B.dk

The exciting contrast between simple and refined materials defines the interior of Formula B: while the floor and lower wall section are clad in natural stone slabs, the remaining wall areas were left in plasterwork.

Der spannungsvolle Kontrast zwischen einfachen und edlen Materialien bestimmt das Interieur des Formel B: Während der Boden und der untere Wandbereich mit Natursteinplatten verkleidet sind, wurden die restlichen Wandflächen als Putzflächen belassen.

Le contraste étonnant entre des matériaux simples et nobles marque l'intérieur du Formel B : le sol et le bas du mur sont revêtus de dalles en pierre naturelle, la surface restante est un mur de crépi nu.

El interior del Formel B está determinado por el excitante contraste que se crea entre los materiales sencillos y los nobles. Si bien el suelo y las partes bajas de las paredes están revestidos de placas de piedra natural, las paredes restantes se han dejado enlucidas.

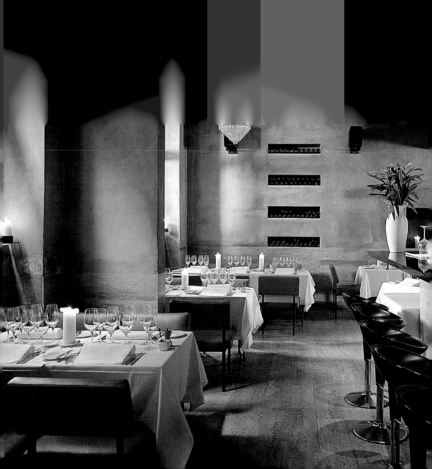

Jacobsen

Ladegaard & Christiansen

Strandvejen 449
Klampenborg

www.restaurantjacobsen.dk
www.lc-ark.dk

The restaurant is part of the famous Bellavista residential complex by Arne Jacobsen. It's true that the original restaurant was already closed at the start of the 1950's. However, today, being restored in exemplary fashion, it's a popular attraction not just for architectural tourists.

Das Restaurant ist Teil der berühmten Bellavista-Wohnanlage von Arne Jacobsen. Zwar wurde das ursprüngliche Restaurant bereits Anfang der fünfziger Jahre geschlossen. Heute jedoch ist es – beispielhaft restauriert – ein beliebter Anziehungspunkt nicht nur für Architekturtouristen.

Le restaurant fait partie du célèbre complexe Bellavista d'Arne Jacobsen. Il est vrai que le restaurant d'origine a été fermé dès le début des années cinquante. Aujourd'hui pourtant, magnifiquement restauré, il est devenu une attraction appréciée, pas seulement des amateurs d'architecture.

El restaurante es parte de la famosa zona residencial Bellavista, de Arne Jacobsen. A principios de los cincuenta se cerró, sin embargo hoy, tras una restauración ejemplar, se ha convertido en uno de los puntos de atracción favoritos, no únicamente para los amantes de la arquitectura.

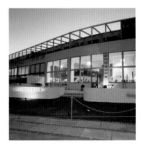

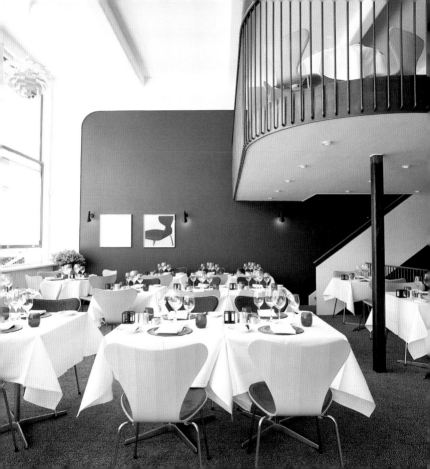

DGI-byen

Schmidt, Hammer & Lassen K/S
Hundsbæk & Henriksen A/S (SE)
NIRAS A/S (SE)

2006
Tietgensgade 65
København V

www.dgi-byen.dk
www.shl.dk
www.hundsbaek.dk
www.niras.dk

Swimming pool, gym, bowling alley, shooting range and climbing wall: DGI City offers possibilities for a whole series of different sports. In the adjoining café and restaurant, there's a chance to regain those lost calories. The variety on offer is complemented by conference rooms and a hotel.

Schwimmbad, Trainingshalle, Bowlingbahn, Schießstand und Kletterwand: Die DGI City bietet Möglichkeiten für eine ganze Reihe unterschiedlicher Sportarten. Im dazugehörigen Café und dem Restaurant kann der Kalorienverlust wieder ausgeglichen werden. Konferenzräume und ein Hotel ergänzen das vielfältige Angebot.

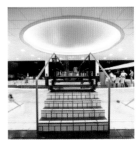

Piscine, salle d'entraînement, piste de bowling, stand de tir et mur d'escalade : la DGI City offre la possibilité de pratiquer toute une série de sports différents. Son café ou son restaurant permettent de regagner facilement les calories perdues. Des salles de conférence et un hôtel complètent cette gamme de prestations.

La piscina, pabellón de entrenamiento, recorrido de bolos, punto de tiro y paredes de escalada dan muestra de que DGI City ofrece posibilidades para practicar los más diversos deportes. La cafetería y restaurante adjuntos ayudan a recuperar las calorías perdidas. La variedad de la propuesta se amplía con la sala de conferencias y el hotel.

Harbour Bath

PLOT
Birch & Krogboe A/S (SE)
CC Design (SE)

2003
Islands Brygge
København S

www.plot.dk
www.birch-krogboe.dk

The harbor is increasingly becoming the cultureal and social center of the city, at least in terms of the traffic and commerce. The new Harbour Bath is also part of this development with its unusual, step-like diving tower.

Der Hafen entwickelte sich vom Verkehrs- und Handelsschwerpunkt immer mehr zum kulturellen und gesellschaftlichen Zentrum der Stadt. Teil dieser Entwicklung ist auch das neue Harbour Bath mit seinem ungewöhnlichen, treppenartigen Sprungturm.

Le port, centre de gravité du commerce et des transports, est en passe de devenir le centre culturel et social de la ville. Cette mutation est illustrée par exemple par le nouveau Harbour Bath avec son plongeoir original en forme d'escalier.

El puerto ha ido desplazando el peso de sus funciones de transporte y comercio para convertirse en el centro cultural y social de la ciudad. Parte de ese desarrollo se hace patente a través del nuevo Harbour Bath, con su atípica torre de trampolín en forma de escalera.

Holmbladsgade Idræts- og kulturhus

Dorte Mandrup Arkitekter ApS
b&k+ brandlhuber&co
Jørgen Nielsen A/S (SE)

Holmbladsgade
København S

www.kvarterloeft.kk.dk
www.dortemandrup.dk
www.brandhuber.com

The sports and cultural center seems to develop out of the gable walls of four rows of houses. The extraordinary form is clad in transparent plastic panels. This ensures fantastic light conditions during the daytime; and at night, the entire building is mysteriously iluminated.

Das Sport- und Kulturzentrum scheint sich aus den Giebelwänden von vier Hauszeilen herauszuentwickeln. Die außergewöhnliche Form ist mit transparenten Kunststoffpaneelen verkleidet. Bei Tag sorgt dies für hervorragende Lichtbedingungen, bei Nacht für ein geheimnisvolles Leuchten des gesamten Baukörpers.

Ce centre sportif et culturel semble être le prolongement des pignons de quatre rangées de maisons. Cette forme inhabituelle est habillée de panneaux plastifiés translucides. Ceci garantit, le jour, une luminosité exceptionnelle, la nuit, un éclat mystérieux à l'ensemble du bâtiment.

El centro deportivo y cultural parece surgir de las fachadas de una hilera de cuatro casas. La atípica forma está revestida de paneles de plástico transparente, lo que proporciona al edificio durante el día condiciones de luz óptimas y durante la noche un especial efecto misterioso.

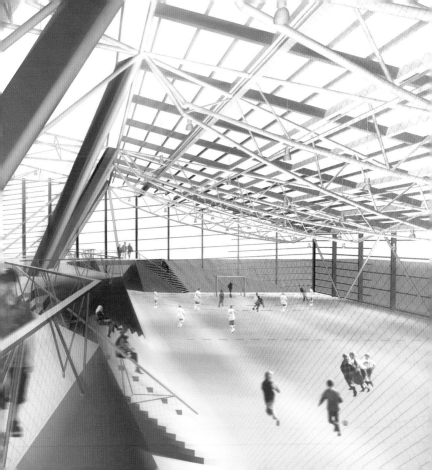

Charlottehaven Health Club

LUNDGAARD & TRANBERG ARKITEKTFIRMA A/S

2004
Hjørringgade 12C
København Ø

www.charlottehaven.com
www.lt-ark.dk

The fitness club is part of the residential complex of Charlottehaven. The swimming pool and gym are separated by a glass wall and can be used both by residents of the apartment buildings as well as external guests.

Der Fitnessclub ist Teil der Wohnanlage Charlottehaven. Schwimmbad und Trainingsraum sind durch eine Glaswand getrennt und können sowohl von den Bewohnern des Wohnkomplexes als auch von externen Gästen benutzt werden.

Le club de fitness fait partie de la résidence Charlottehaven. La piscine et la salle d'entraînement sont séparés par une cloison de verre et sont accessibles aussi bien aux habitants de la résidence qu'au public venant de l'extérieur.

El Fitnessclub es parte de la zona residencial de Charlottehaven. La piscina y las salas de entrenamiento están separadas por una vidriera y a ellas tienen acceso tanto los habitantes del recinto como visitantes externos.

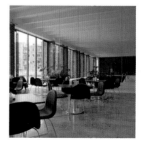

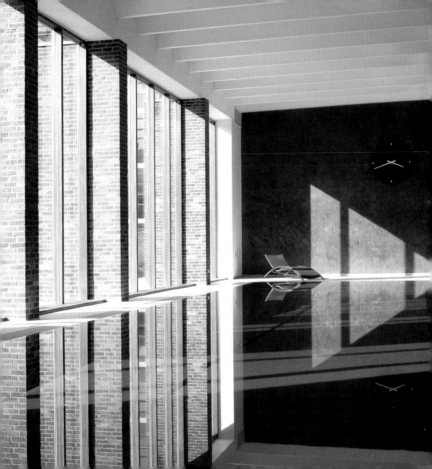

Kildeskovshallen
Public Bath

Entasis A/S – Christian Cold
NIRAS A/S (SE)

2002
Adolphsvej 25
Gentofte

www.entasis.dk
www.niras.dk

The aesthetic form of this sports pool is almost ascetic. The swimming pool dominates the architecture, nothing is meant to divert the attention of the audience from the contest of the athletes.

Geradezu asketisch erscheint die Ästhetik dieses Sportbades. Das Schwimmbecken steht im Zentrum der Architektur, nichts soll die Aufmerksamkeit des Publikums vom Wettkampf der Athleten ablenken.

L'esthétique de cette piscine olympique est quasi ascétique. Le grand bassin est le point central de l'architecture, rien d'autre ne doit détourner l'attention du public des athlètes en compétition.

La estética de esta piscina polideportiva es extremadamente sobria. La piscina está ubicada en el centro del edificio, para que nada distraiga la atención de los espectadores durante las competiciones de los atletas.

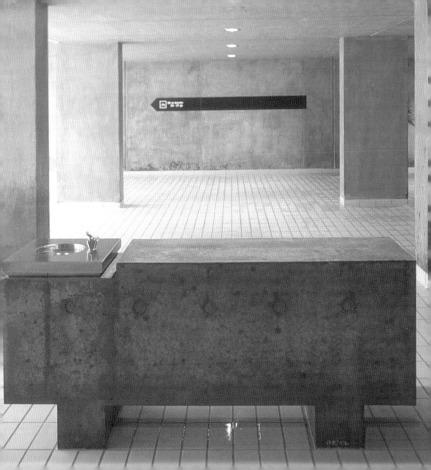

to shop . mall
 retail
 showrooms

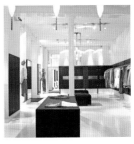
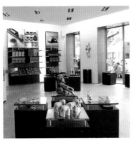
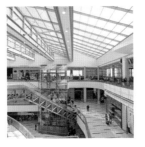
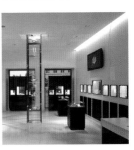
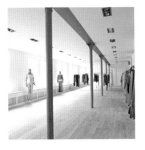
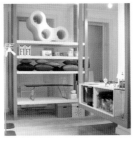
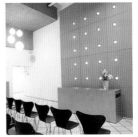

Georg Jensen's Flagship Store

Hvidt & Mølgaard A/S Arkitektfirma

2003
Amagertorv 4
København K

www.georgjensen.com
www.hm-ark.dk

A large, black wall panel stands in the center of the elegant business floor. Running parallel to this, a staircase leads to the upper floor. The length of the stairs is emphasized by a trick of perspective. The purist aesthetic of the interior furnishing offers the perfect setting for the refined items on offer by the silversmith.

Eine große, schwarze Wandscheibe steht im Zentrum der noblen Geschäftsräume. Parallel dazu führt eine Treppe in das Obergeschoss, deren Länge durch einen perspektivischen Trick betont wird. Die puristische Ästhetik der Innenausstattung bildet den perfekten Rahmen für die edlen Waren der Silberschmiede.

Une grand cloison noire se dresse au centre de ce magasin raffiné. Parallèlement, un escalier dont la longueur est soulignée par un artifice de perspective mène à l'étage supérieur. L'esthétique puriste de la décoration intérieure crée un cadre parfait pour les objets précieux des orfèvres.

En el centro del elegante comercio se levanta una gran pared de color negro; paralela a ella se erige una escalera de acceso a la planta superior, cuya longitud se ha acentuado a través de juegos de perspectiva. La estética purista creada en el interior conforma el marco perfecto para los valiosos artículos de plata que se exponen.

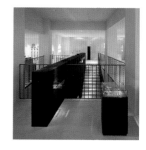

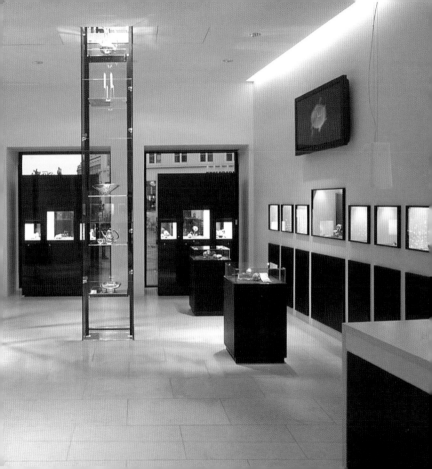

Rosendahl

Kim Utzon

2003
Bremerholm 1
København K

www.rosendahl.com
www.utzon-arkitekter.dk

The reduction to black, white and grey tones as well as the use of a few, high quality materials defines the character of this retail outlet. A large shelf unit opposite the entrance forms an optical focal point of the room.

Die Reduktion auf Schwarz, Weiß und Grautöne sowie die Verwendung weniger, hochwertiger Materialien bestimmen den Charakter des Ladengeschäftes. Ein großes Schrankelement gegenüber dem Eingang bildet den optischen Schwerpunkt des Raumes.

Le cachet de ce magasin se fonde sur un emploi réduit des couleurs – noir, blanc et nuances de gris – et de rares matériaux de grande valeur. Le seul accent visuel que comporte cet espace est une grande armoire murale en face de l'entrée.

El carácter de este comercio está determinado por la reducción de colores al blanco, negro y los tonos grises, así como por el empleo de menor cantidad de materiales aunque siendo éstos de mayor valor. El punto clave de este edificio desde el punto de vista óptico es el gran armario que está situado frente a la entrada.

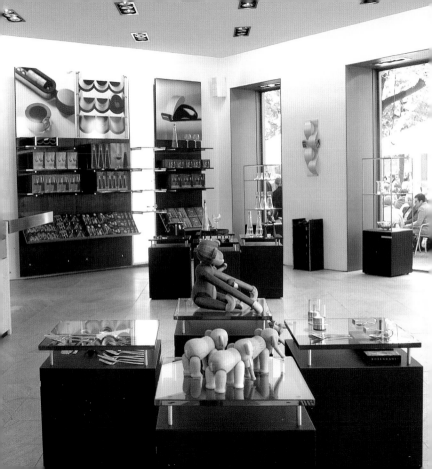

Hay Shop

Leif Jørgensen, Rolf Hay

Pilestræde 29-31
København K

www.hay.dk

Unconventional designs by young Danish designers are on show in this two-storey store. Shelves with intense green supports stand on the floor, hang on the wall or seem to penetrate the ceiling in the store.

Unkonventionelle Entwürfe junger dänischer Designer werden in diesem zweigeschossigen Laden präsentiert. Regale mit kräftigen grünen Stützen stehen auf dem Boden, hängen an der Wand oder scheinen die Zwischendecke des Geschäftes zu durchdringen.

Les ébauches peu conventionnelles de jeunes designers danois sont présentées sur deux étages dans ce magasin. Des étagères sont plantées dans le sol sur de solides supports verts, sont accrochées aux murs ou semblent traverser le faux-plafond du magasin.

Este comercio de dos plantas presenta esbozos fuera de lo convencional de jóvenes diseñadores daneses. Las estanterías con apoyos en verde intenso se levantan desde el suelo, cuelgan de la pared o parecen atravesar el techo intermedio del comercio.

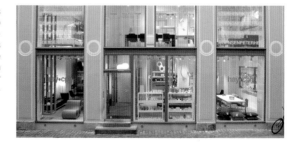

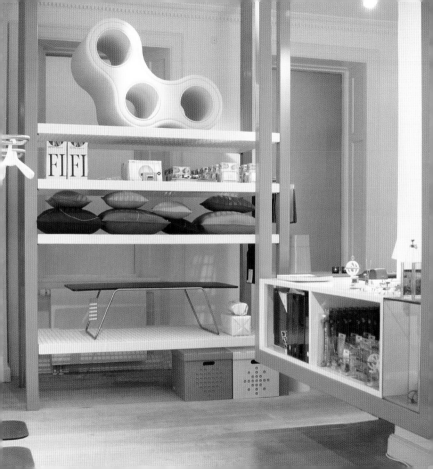

munthe plus
simonsen image store

Naja Munthe & Karen Simonsen

2003
Grønnegade 10
København K

www.muntheplussimonsen.dk

The Image Store of the Danish fashion label regards itself as an oasis of calm in the heart of the city. All interior surfaces as well as columns and ceiling supports are kept in pure white; in contrast to this, the wall panels are made out of buffalo hide and store fittings are in dark wood tones.

Als Oase der Ruhe im Herzen der Stadt versteht sich der Image Store des dänischen Modelabels. Sämtliche Oberflächen des Innenraumes sowie Stützen und Deckenträger sind in reinem Weiß gehalten; in Kontrast dazu stehen Wandpaneele aus Büffelleder und die dunklen Holztöne der Ladeneinrichtung.

Au cœur de la ville, l'Image Store de cette griffe de mode danoise se présente comme une oasis de calme. Toutes les surfaces de l'intérieur ainsi que les piliers et les poutres sont délibérément blancs ; ceci contraste avec les panneaux muraux en cuir de buffle et le bois sombre des meubles du magasin.

El comercio de la marca danesa es un verdadero oasis de tranquilidad en el corazón de la ciudad. Tanto las superficies de los interiores como los apoyos y las vigas se han mantenido en un blanco diáfano. El contraste lo crean los paneles de las paredes en piel de búfalo y los tonos oscuros de la madera.

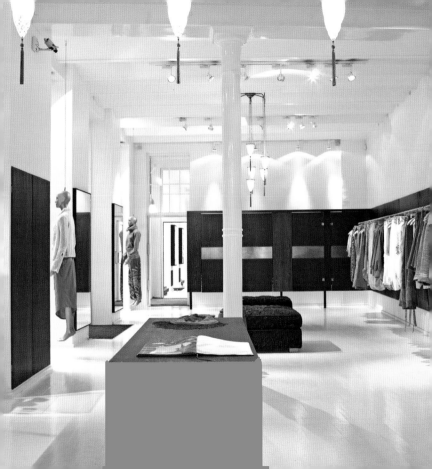

Louis Poulsen Showroom

Louis Poulsen

2000
Nyhavn 11
København K

www.louis-poulsen.dk

Lamps and lighting ideas are on show here on an area of over 700 m². Anthracite colored frames have a structuring and linking effect between the different exhibition areas.

Auf über 700 m² werden hier Leuchten und Lichtkonzepte präsentiert. Anthrazitfarbene Rahmen wirken als gliedernde und verbindende Elemente zwischen den verschiedenen Ausstellungsbereichen.

Luminaires et concepts d'éclairage sont présentés ici sur plus de 700 m². Des cadres anthracite figurent des éléments articulant et reliant les différents départements de l'exposition.

En un espacio de 700 m² se presentan diversos conceptos de iluminación. Los marcos de color antracita sirven de elementos de unión entre las diversas zonas de exposición.

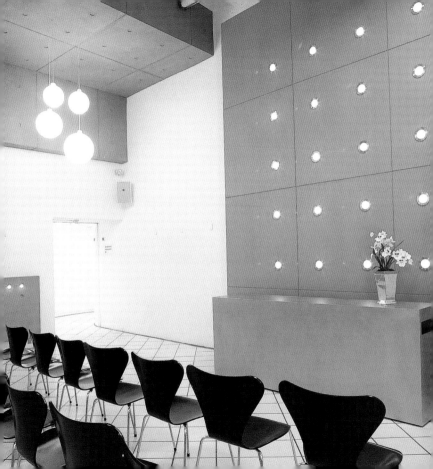

Boghandel
Dansk Arkitektur Center

Dorte Mandrup Arkitekter ApS

2000
Strandgade 27B
København K

www.dac.dk
www.dortemandrup.dk

The interior of the book store, not just what's on offer, is of interest to architects and designers. The entire interior was made up out of simple wooden sections; even the sales counter and side areas of the stairwell serve as book shelves.

Nicht nur das Angebot, auch das Interieur der Buchhandlung ist für Architekten und Designer interessant. Die gesamte Ausstattung wurde aus einfachen Holzplatten zusammengefügt; auch der Verkaufstresen und die Seitenbereiche des Treppenhauses dienen als Bücherregale.

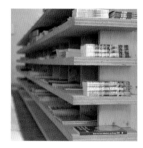

Pour les architectes et les designers, non seulement l'offre mais aussi l'intérieur de cette librairie sont intéressants. Toute l'installation a été réalisée au moyen de simples plaques de bois ; le comptoir et les espaces aux flancs de la cage d'escalier servent d'étagères pour les livres.

Tanto la oferta en libros como el interior de la librería resultan interesantes para arquitectos y diseñadores. El equipamiento se ha configurado a partir de simples paneles de madera. Los mostradores y los laterales de la escalera hacen la función de estantería para libros.

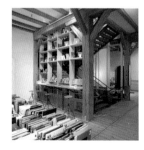

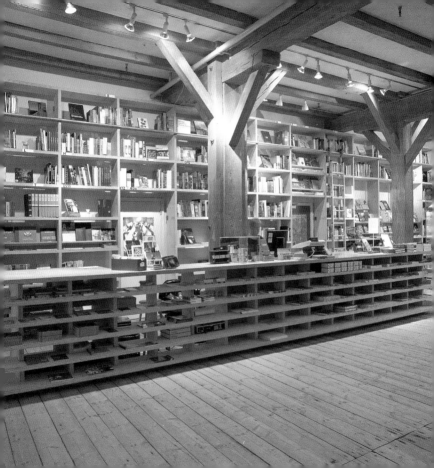

ManRec Showroom

Johannes Torpe Studios ApS

1997
Fredriksborggade 37
København K

www.manrec.com
www.johannestorpe.com

The CDs of the same label are displayed in an unusual way in this shop: head-phones hang from the ceiling of the room, inviting customers to embark on musical voyages of discovery.

Die CDs des gleichnamigen Labels werden in diesem Laden auf ungewöhnliche Weise präsentiert: Von der Decke des Raumes hängen Kopfhörer, die zu musikalischen Entdeckungsreisen einladen.

Les CDs produits par le label du même nom sont présentés dans ce magasin de façon très originale : des écouteurs pendent du plafond du magasin et invitent les clients à des voyages de découvertes musicales.

En este comercio los CDs de la marca del mismo nombre se presentan de la forma más peculiar. Del techo cuelgan auriculares que invitan a un viaje a través de la música.

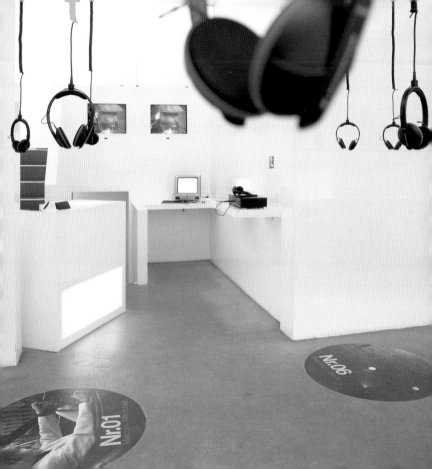

Field's

C. F. Møller Architects
NIRAS A/S (SE)

2004
Arne Jacobsens Allé 12
København S

www.fields.dk
www.cfmoller.com
www.niras.dk

The gigantic shopping center measuring an overall surface area of 115,000 m² is regarded as Scandinavia's largest shopping mall. Three shopping levels and two floors with offices are located above two underground garages. Natural light can flood into all areas of the shops through massive up-lighters.

Das riesige Einkaufszentrum mit einer Gesamtfläche von 115.000 m² gilt als größte Mall Skandinaviens. Über zwei Tiefgaragen liegen hier drei Einkaufsebenen und zwei Bürogeschosse. Durch große Oberlichter kann natürliches Licht in alle Ladenbereiche dringen.

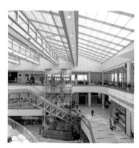

Cet immense centre commercial qui couvre une surface de 115.000 m² passe pour être le plus grand de Scandinavie. Au-dessus de deux parkings souterrains s'étendent trois niveaux de magasins et deux étages de bureaux. Grâce à de très grandes impostes la lumière naturelle peut pénétrer dans tous les magasins.

El enorme centro comercial tiene una superficie de 115.000 m² y se considera el más grande de Escandinavia. El edificio cuenta con dos garajes subterráneos, tres plantas comerciales y dos de oficinas. Las amplias claraboyas permiten que la luz natural penetre en todos los espacios.

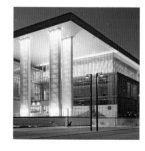

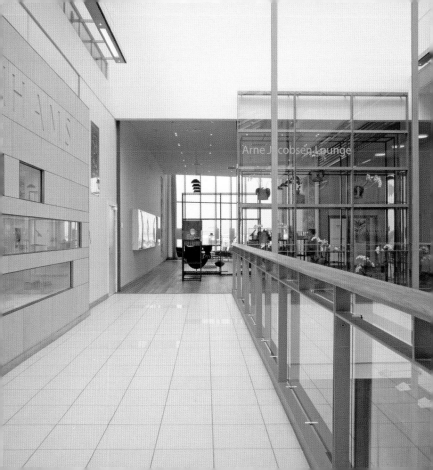

munthe plus
simonsen showroom

Naja Munthe & Karen Simonsen

2003
Ryesgade 3A
København N

www.muntheplussimonsen.dk

In this showroom, the latest collections are introduced to a select audience—fashion experts, buyers and journalists. The soft, light colorfulness of the interior provides the perfect backdrop for this. Olive trees in simple terracotta pots emphasize the minimalist elegance of the interior.

In diesem Showroom werden die neuesten Kollektionen einer ausgewählten Öffentlichkeit – Modeexperten, Händlern und Journalisten – vorgestellt. Die sanfte, helle Farbigkeit des Interieurs liefert dafür den perfekten Hintergrund. Olivenbäume in einfachen Tongefäßen unterstreichen die minimalistische Eleganz des Innenraums.

Ce Showroom présente les dernières collections de personnalités triées sur le volet – spécialistes de la mode, distributeurs et journalistes. Pour cela, la dominante de couleur claire et douce de l'intérieur crée une parfaite toile de fond. Des oliviers plantés dans de simples poteries soulignent l'élégance minimaliste des pièces.

En esta Showroom se presentan las últimas colecciones de los prominentes del mundo de la moda, el comercio y el periodismo. Las tonalidades claras y ligeras de los interiores crean el trasfondo perfecto. Los olivos y vasijas de barro destacan la elegancia minimalista del espacio interior.

Index Architects / Designers

Index Structural Engineers

Index Districts

Index Districts

Photo Credits

Imprint

Copyright © 2005 teNeues Verlag GmbH & Co. KG, Kempen

Published by teNeues Publishing Group

teNeues Book Division
Kaistraße 18
40221 Düsseldorf, Germany
Phone: 0049-(0)211-99 45 97-0
Fax: 0049-(0)211-99 45 97-40
E-mail: books@teneues.de

Press department: arehn@teneues.de
Phone: 0049-(0)2152-916-202

www.teneues.com
ISBN-10: 3-8327-9077-2
ISBN-13: 978-3-8327-9077-6

teNeues Publishing Company
16 West 22nd Street
New York, N.Y. 10010, USA
Phone: 001-212-627-9090
Fax: 001-212-627-9511

teNeues Publishing UK Ltd.
P.O. Box 402
West Byfleet
KT14 7ZF, UK
Phone: 0044-1932-403 509
Fax: 0044-1932-403 514

teNeues France S.A.R.L.
4, rue de Valence
75005 Paris, France
Phone: 0033-1-55 76 62 05
Fax: 0033-1-55 76 64 19

teNeues Iberica S.L.
Pso. Juan de la Encina 2–48,
Urb. Club de Campo
28700 S. S. R. R., Madrid, Spain
Phone: 0034-91-65 95 876
Fax: 0034-91-65 95 876

Bibliographic information published by Die Deutsche Bibliothek
Die Deutsche Bibliothek lists this publication in the Deutsche Nationalbibliografie;
detailed bibliographic data is available in the Internet at http://dnb.ddb.de

Concept of and:guides by Martin Nicholas Kunz

Edited by Christian Datz and Christof Kullmann
Layout & Pre-press: Thomas Hausberg
Imaging: Jan Hausberg
Map: go4media. – Verlagsbüro, Stuttgart

Translation: SAW Communications,
 Dr. Sabine A. Werner, Mainz
 English: Dr. Suzanne Kirkbright
 French: Brigitte Villaumié
 Spanish: Silvia Gómez de Antonio

fusion-publishing stuttgart . los angeles www.fusion-publishing.com

Printed in Italy

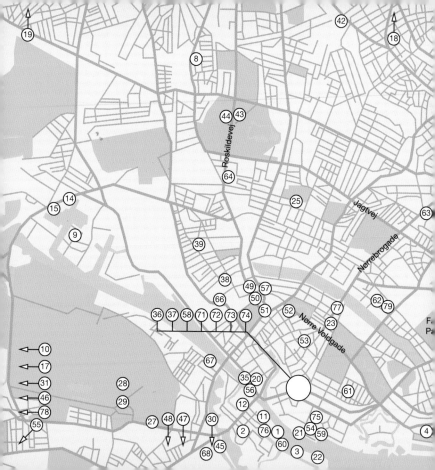

Legend

191

and : guide

Size: 12.5 x 12.5 cm / 5 x 5 in. (CD-sized format)
192 pp., Flexicover
c. 200 color photographs and plans
Text in English, German, French, Spanish

Other titles in the same series:

Amsterdam
ISBN: 3-8238-4583-7
Barcelona
ISBN: 3-8238-4574-8
Berlin
ISBN: 3-8238-4548-9
Chicago
ISBN: 3-8327-9025-X
Hamburg
ISBN: 3-8327-9078-0
London
ISBN: 3-8238-4572-1
Los Angeles
ISBN: 3-8238-4584-5
Munich
ISBN: 3-8327-9024-1

New York
ISBN: 3-8238-4547-0
Paris
ISBN: 3-8238-4573-X
Prague
ISBN: 3-8327-9079-9
San Francisco
ISBN: 3-8327-9080-2
Shanghai
ISBN: 3-8327-9023-3
Tokyo
ISBN: 3-8238-4569-1
Vienna
ISBN: 3-8327-9026-8

To be published in the same series:

Dubai
Dublin
Hong Kong
Madrid
Miami

Moscow
Singapore
Stockholm
Sydney
Zurich

teNeues

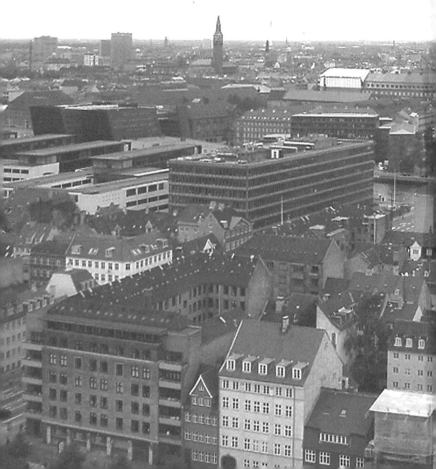